Historic England

# Bradford

Paul Chrystal

AMBERLEY

# Acknowledgements

A number of the photographs and images in this book have been made available by various individuals and organisations. It gives me pleasure to thank Margaret Silver and Simon Palmer for permission to use the Simon Palmer watercolours published in Jim Greenhalf's *Salt & Silver*. Some of the Saltaire images appear in my *Old Saltaire and Shipley* title (2014); some of the Bradford pictures appear in my *Bradford at Work* title (2018).

# About the Author

Paul Chrystal was educated at the universities of Hull and Southampton. He has worked in medical publishing for over thirty-five years, but now combines this with writing features for national newspapers and history magazines as well as advising visitor attractions such as the National Trust's Goddards, the York home of Noel Terry, and York's Chocolate Story. He appears regularly on BBC local radio and has featured on BBC World Service and on Radio 4's *PM* programme. He is the author of around 100 books on a wide range of subjects, including a number of social histories of various towns and cities in Yorkshire, and aspects of ancient history. He is married with three children and lives near York.

paul.chrystal@btinternet.com

First published 2018

Amberley Publishing
The Hill, Stroud, Gloucestershire, GL5 4EP
www.amberley-books.com

Copyright © Paul Chrystal, 2018

The right of Paul Chrystal to be identified as the Author of this work has been asserted in accordance with the Copyright, Designs and Patents Act 1988.

ISBN 978 1 4456 8360 7 (print)
ISBN 978 1 4456 8361 4 (ebook)

British Library Cataloguing in Publication Data.
A catalogue record for this book is available from the British Library.

Origination by Amberley Publishing.
Printed in Great Britain.

# Contents

Introduction                          5

Public Buildings                      6

Religious Buildings                   29

Industry                              40

Business                              62

Schools and Universities             69

Parks                                 73

People                                79

Saltaire                              82

About the Archive                     96

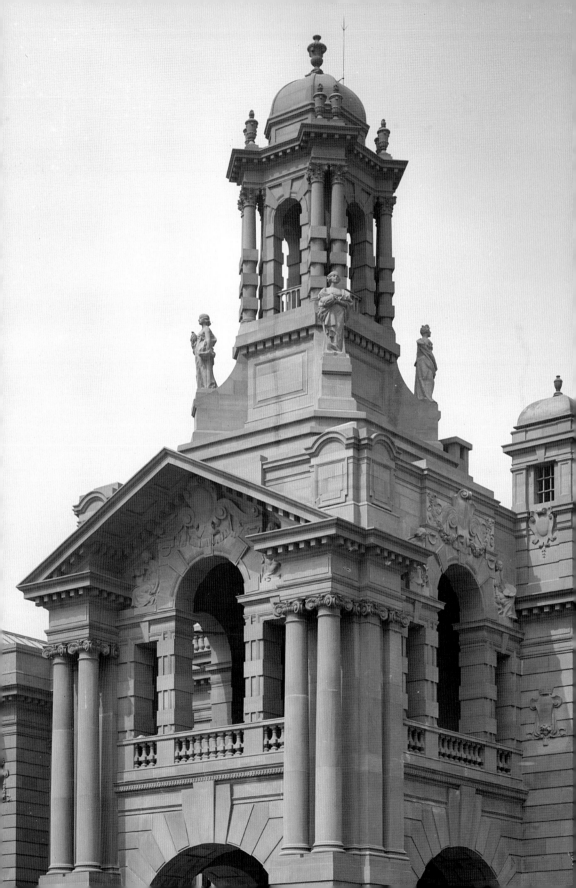

# Introduction

Many books exist showing pictures of Bradford from the nineteenth and twentieth centuries. This book, however, is decidedly different from all its predecessors because it features images from the unique and rarely seen photographic archive of Historic England.

Bradford, or at least the Bradford of the nineteenth and early to mid-twentieth centuries, was defined by mills, ironworks, mines and textiles. Henry VIII's reign (1509–47) had seen Bradford exceed Leeds as a manufacturing centre and the start of two hundred years of relentless growth, with it ultimately becoming the UK's premier wool trade town. In the eighteenth century the Bradford Canal (1774) and turnpike road links boosted trade and industry yet further – the canal ran the 3 miles from the city centre to join the Leeds and Liverpool Canal at Windhill. Although traffic had diminished by 1894, coal was still being shipped into the city in the 1930s. Another driver of progress came at the end of the nineteenth century with the completion in 1896 of the Bradford Midland station.

All of this and more is pictured here, including Bradford's traditional industries, leading universities and colleges, magnificent civic buildings, religious buildings, theatres, parks and commercial buildings. The final chapter is given over to Saltaire, which was built by Titus Salt, a prominent Bradford mill owner who decamped to a site 4 miles north of the centre of Bradford and constructed his famous industrial village there.

# Public Buildings

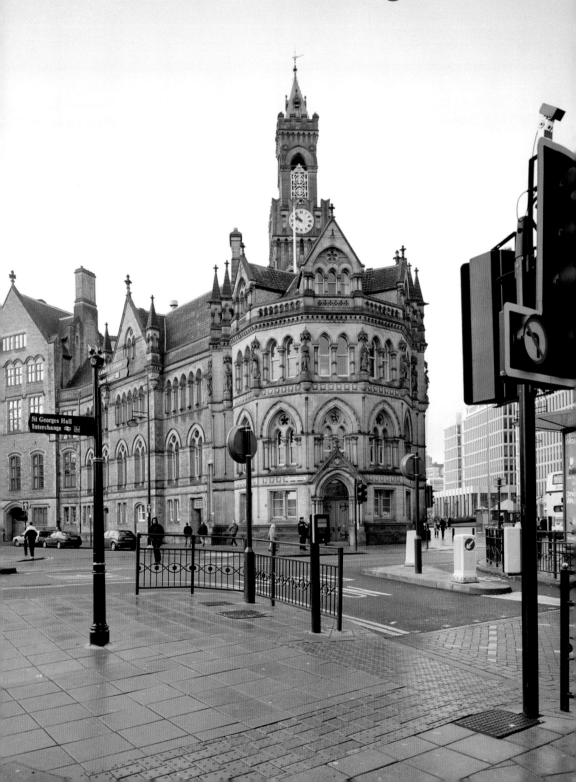

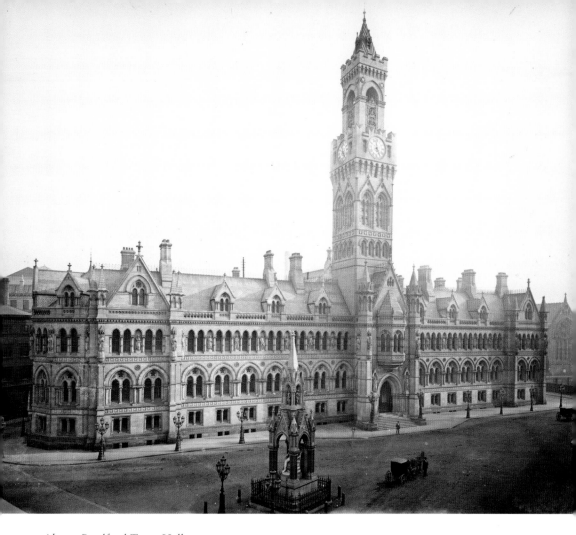

*Above*: Bradford Town Hall
An exterior view of the Town Hall from the north, with the statue of Titus Salt in the foreground in 1905. (Historic England Archive)

*Opposite*: Bradford Town Hall
Bradford Town Hall's design is the result of a competition, which was won by Lockwood & Mawson in 1869. The building was completed in 1873 and extended in 1905–09, and was ambitious enough to compete with Leeds' and Halifax's town halls. The Town Hall continues to dominate the centre of Bradford, with its campanile still a prominent landmark. Winston Churchill gave a speech here after the Second Battle of El Alamein, in which he called for the people to 'go forward together and put these grave matters to the proof'. In 1965 the name was changed to City Hall. In 1992 the bells stopped ringing due to a rotting bell frame, but in 1997 they were repaired with National Lottery funds. Recently, the bells have played 'The Star-Spangled Banner' to mark the three minutes' silence for those who died due to terrorism. When an eminent Bradfordian dies, the City Hall flags fly at half-mast until the end of the funeral, while the minute bell rings for an hour after receipt of notice, and for an hour at the time of the funeral. According to the *Telegraph* on 11 May 2005, at the memorial of the 1985 Bradford City stadium fire 'dozens of people broke down in tears as the City Hall bells played "You'll Never Walk Alone" and "Abide with Me" in tribute to the victims'. (© Historic England Archive)

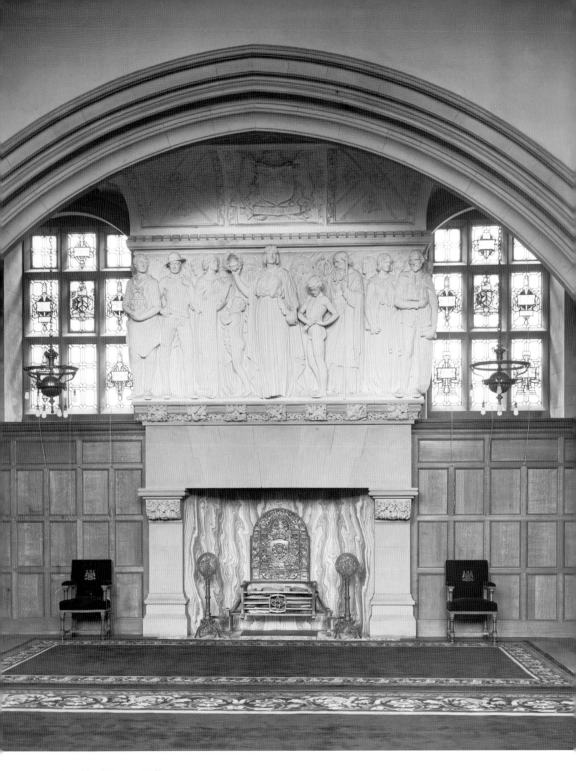

Bradford Town Hall
A sculpted overmantel representing 'Progress' in the banqueting hall of the Bradford Town Hall
extension. It was carved by the firm Earp, Hobbs & Millar. (Historic England Archive)

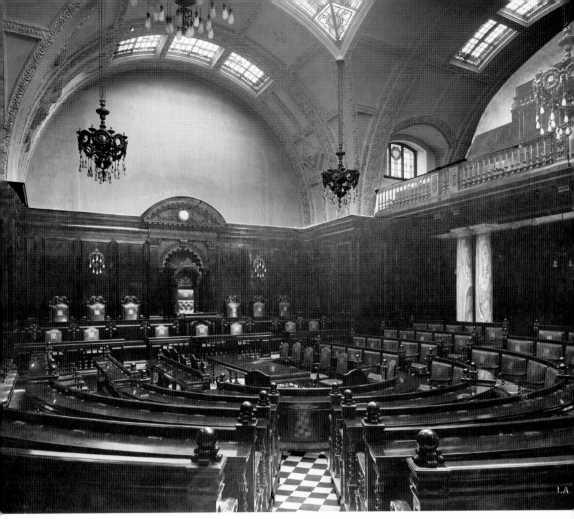

*Above*: The council chamber in the Bradford Town Hall extension. (Historic England Archive)

*Right*: Bradford Town Hall
The banqueting hall in the Bradford Town Hall extension, looking towards a splendid stained-glass window. (Historic England Archive)

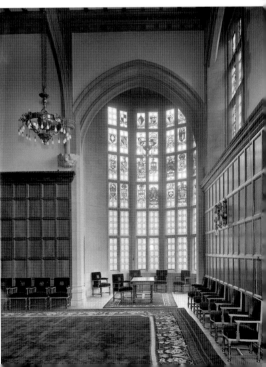

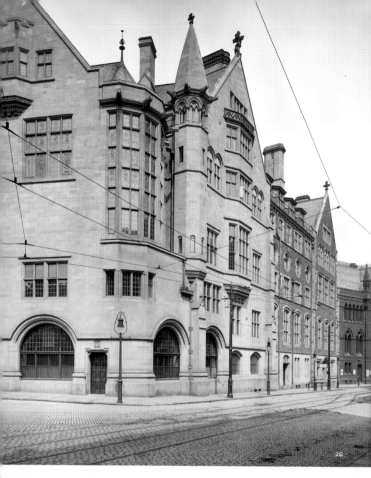

26

*Left and below*: Bradford Town Hall
The south-east corner of the Bradford Town Hall extension in 1910 and 2007. (© Historic England Archive)

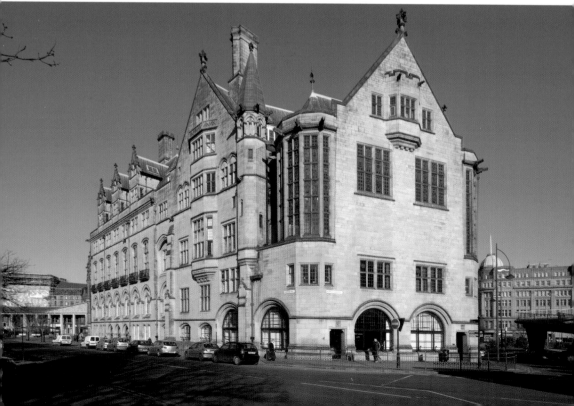

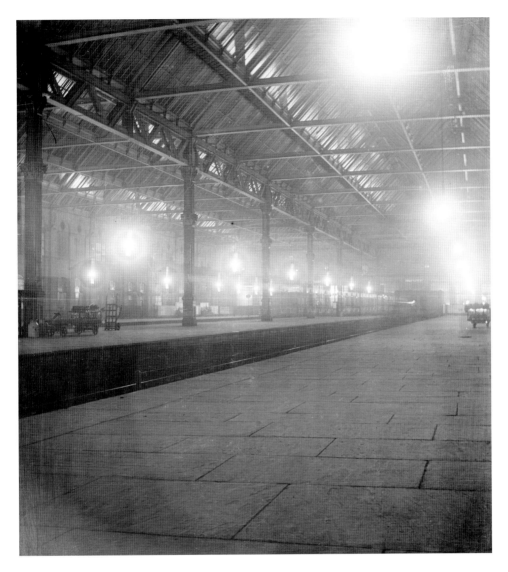

*Above and overleaf above*: Midland Railway Station

Two views of the Midland Railway station around the end of the nineteenth century. The city's first station was opened in 1846 by the Leeds & Bradford Railway, operating a line from Leeds Wellington Street (now Leeds City station) via the Aire Valley and Shipley. Until then Bradford's nearest station was Brighouse (then known as Brighouse for Bradford), which opened in 1840 and was located off Kirkgate. In 1850, the Lancashire & Yorkshire Railway built another station, known as Bradford Exchange, to the south of the city centre off Hall Ings. In 1853, the rapidly expanding Midland Railway took over the Leeds & Bradford Railway and the first Bradford station was rebuilt. Another station, Bradford Adolphus Street, came along in 1854 courtesy of the Leeds, Bradford & Halifax Junction Railway. This station was short-lived, however, as it was closed to passengers in 1867 and the services were diverted to Bradford Exchange. The site of Bradford Exchange now houses Bradford Crown Court. The second image shows the station in 1919. (Historic England Archive; Paul Chrystal)

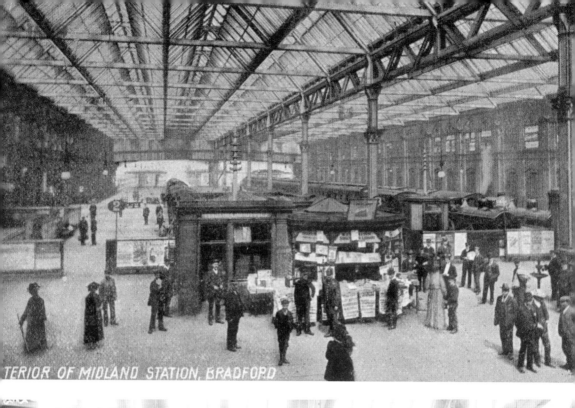

TERIOR OF MIDLAND STATION, BRADFORD

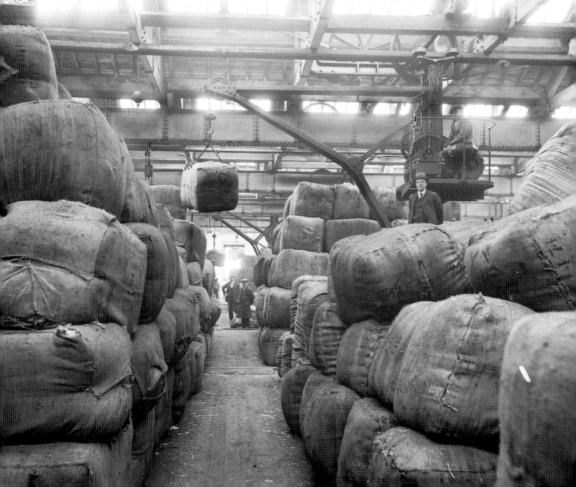

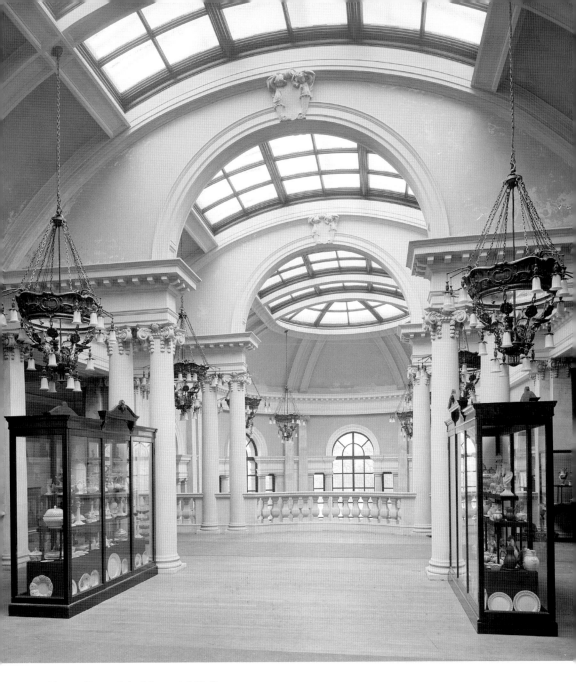

*Above*: Cartwright Memorial Hall
Inside the Cartwright Memorial Hall, showing the colonnade in 1905. (Historic England Archive)

*Opposite below*: Bridge Street Goods Station
Evidence for Bradford's textile industry heritage in 1929. This image shows figures standing among the stacks of packaged wool on the top floor of the warehouse at Bridge Street Goods Station, with a crane operator at work moving a single bale. The Bradford Exchange was closed in 1973 and replaced by a smaller four-platform station 50 yards south on part of the site of the Bridge Street Goods Depot, which was demolished at the same time. (Historic England Archive)

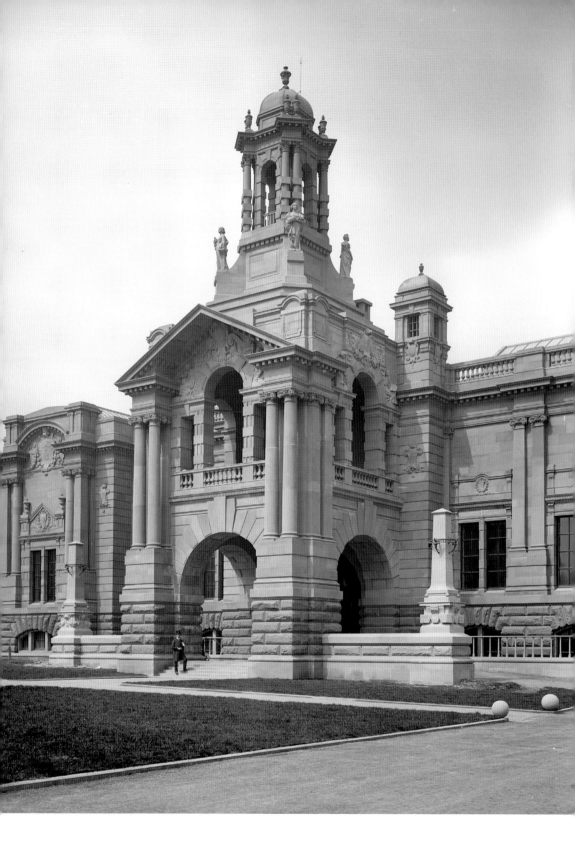

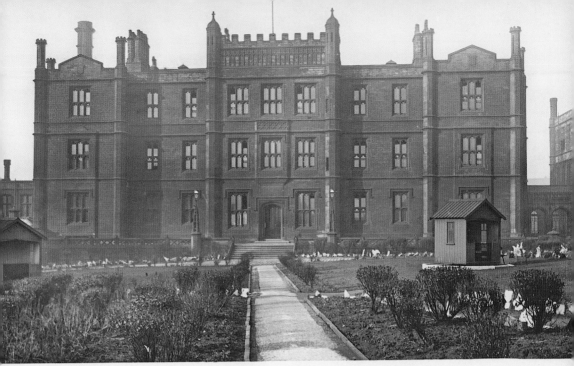

INFIRMARY, BRADFORD.

*Above*: Bradford Infirmary
This image shows the first infirmary, which was built in 1843. The current Bradford Royal Infirmary (BRI) was built in 1936. (Paul Chrystal)

*Opposite*: Cartwright Memorial Hall
Anne Bishop gives the story behind Bradford's art gallery:

One day in the spring of 1898 an ageing Lord Masham paid a visit to Manningham Park, the estate which Bradford Corporation had purchased from him in 1870 at half real value. He was shocked to see the hall which had been his home from boyhood to early married life now in a shabby and dilapidated condition, being used as a second-class restaurant. The scene so disturbed him that in May he wrote to Thomas Speight, the Mayor, asking for an hour's conversation with him. When this took place Lord Masham said he would like to do something for Bradford, and suggested that the old Manningham Hall be demolished and replaced by a permanent memorial to Dr Edmund Cartwright, the man to whom he and Bradford owed so much. During lunch with the Mayor and a few friends Lord Masham offered a gift of £40,000 (the sum paid by the Corporation for Manningham Park) towards the cost.

The Corporation accepted the offer most readily and proposed that the new hall should take the form of a technological museum. This would have been a most fitting tribute to Cartwright, who, by inventing the power loom and the combing machine had played such a large part in Bradford's rise to fame and prosperity; but the Technical College, which opened in 1882, seemed a more appropriate place for exhibitions of a scientific nature. Instead, a proposal was made to erect an Art Gallery and Natural History Museum with reception rooms for municipal functions.

(First published in *The Bradford Antiquary: The Journal of the Bradford Historical and Antiquarian Society*, Series 3, Volume 4, 1989, pp. 26–38) (Historic England Archive)

CHILDREN'S HOSPITAL, BRADFORD.

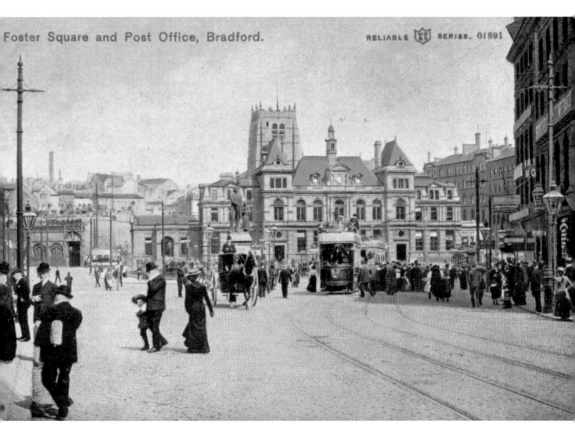

Foster Square and Post Office, Bradford.     RELIABLE [K] SERIES. 01891

*Above*: Forster Square
Forster Square was laid out in the late nineteenth century at the bottom of Kirkgate and takes its name from the nineteenth-century politician William Edward Forster. (Paul Chrystal)

*Opposite*: Bradford Children's Hospital
An exterior view of the former Bradford Children's Hospital in 2007. The closure in 2006 of the Nightingale Nursing Home in St Mary's Road, Manningham, ended another chapter in the life of the building that opened on 7 October 1890 as Bradford Children's Hospital. It remained, with its distinctive round wards, until July 1987 when the children's hospital services transferred to St Luke's and the old hospital closed, reopening two years later as a private nursing home. (© Historic England Archive; Paul Chrystal)

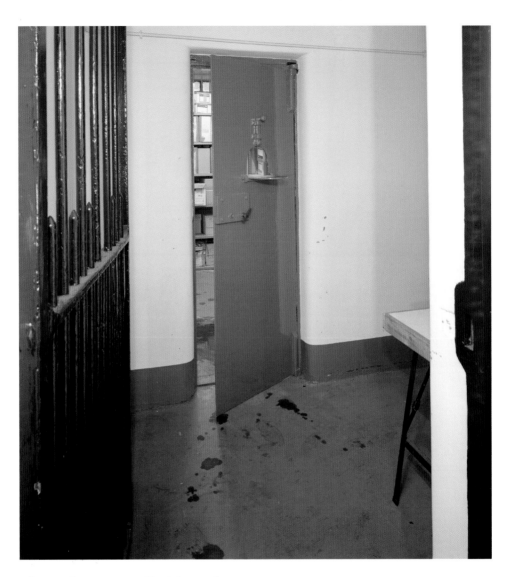

*Above and opposite*: Bradford Crown Court
Two views no one will want to see first hand. The image above shows a typical cell door inside Bradford Crown Court. The image opposite shows the stairway descending from the dock to the cells. (© Historic England Archive)

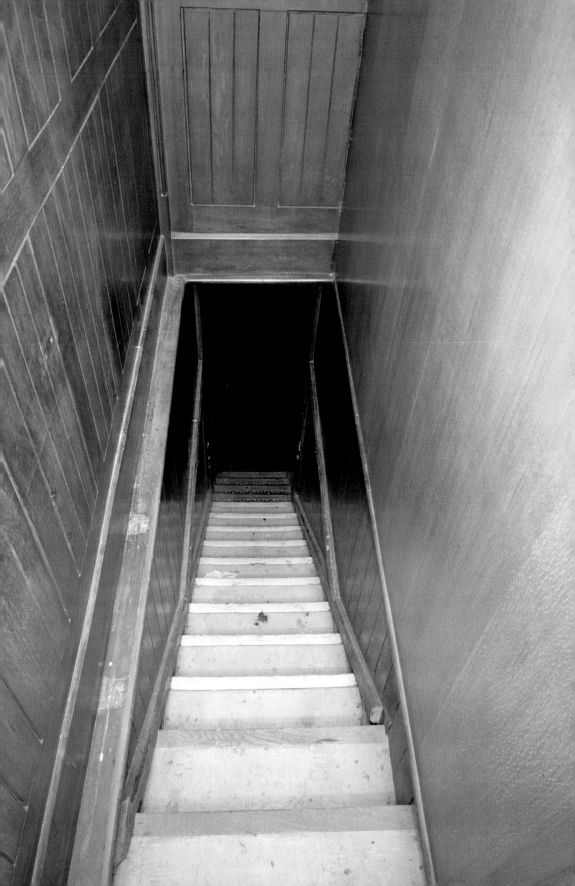

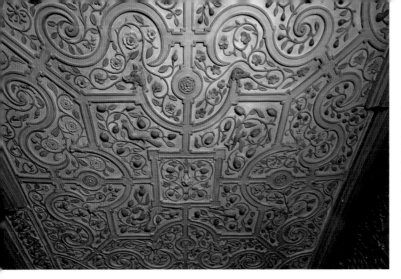

Bolling Hall
A view of the detailed decorated plaster ceiling at Bolling Hall in 2007. Dating partially from the fourteenth century, Bolling Hall is one of the oldest buildings in Bradford. It is currently used as a museum and education centre. (© Historic England Archive)

St George's Hall
St George's Hall in 2007. The £8.5 million refurbishment of this Grade II-listed building has yielded many fascinating objects, including a handbill from 1871 promoting a programme of Saturday night entertainment that was printed by J. Clegg Printer by Steam Power. The programme for the evening included Madam Tonnelier performing songs in character from the Grand Duchess, as well as a line-up of music and sketches including Irish and Scottish songs and stories by Mr and Mrs Forster O'Neill accompanied on the piano by their daughter Flora. Workers also found the front page of the *Daily Express* from 10 January 1928 during the refurbishment. The front page contains an article about plans to build a barrage in the wake of the Great Flood of London, which had taken place only a few days earlier on 7 January 1928. Other items include a wrapper from a Cadbury's Flake (costing 6*d*) and several cigarette packets, including a Black Cat Cigarettes tin lid from the 1930s. (© Historic England Archive)

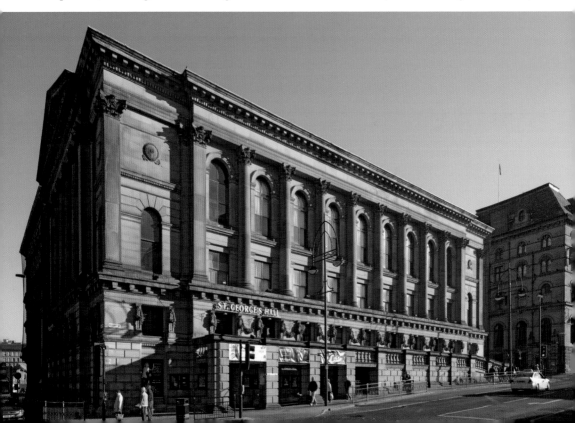

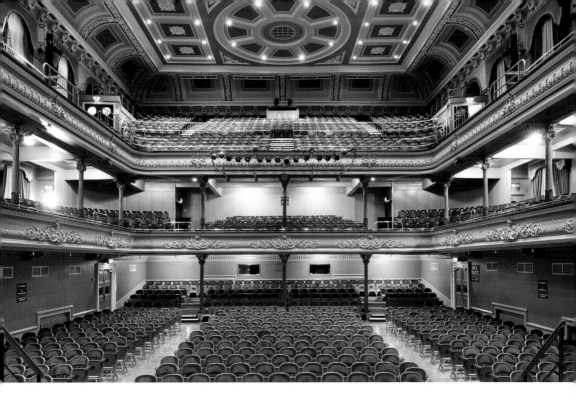

*Above, below and overleaf above*: St George's Hall
Three interior views of the theatre looking towards the stalls, dress circle and grand tier seating.
(© Historic England Archive)

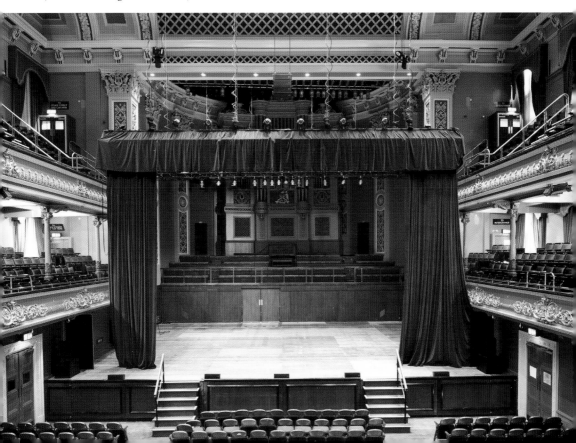

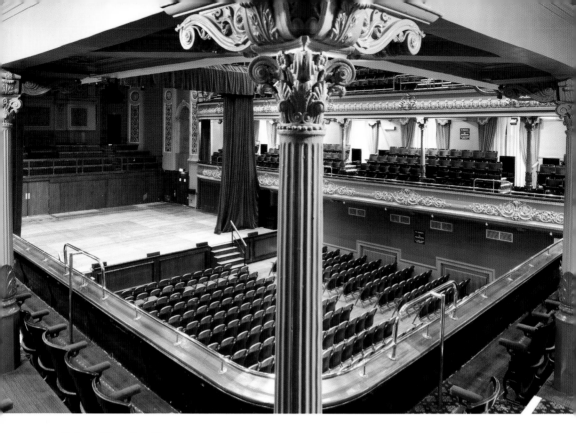

*Below*: Alhambra Theatre

The Alhambra Theatre is named after the Alhambra palace in Granada, Spain, the residence of the Emir of the Emirate of Granada. It was built in 1913 at a cost of £20,000 and opened on Wednesday 18 March 1914. The main house seats 1,400 people. (Paul Chrystal)

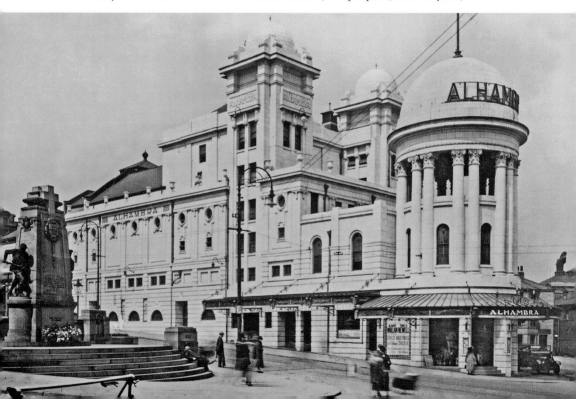

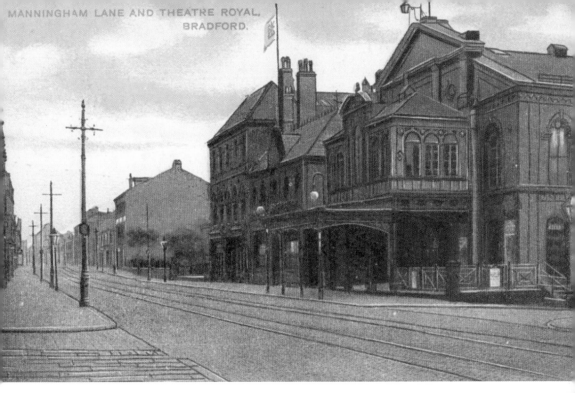

MANNINGHAM LANE AND THEATRE ROYAL, BRADFORD.

*Above*: Theatre Royal
The Theatre Royal in Manningham Lane (not to be confused with the earlier Theatre Royal on Duke Street) originally opened as the Alexandra Theatre on Boxing Day in 1864 with the pantomime *All That Glitters Is Not Gold*. Later renamed the Theatre Royal, it was the last theatre that Henry Irving performed in before his death in October 1905 at Bradford's Midland Hotel after a performance of *Becket*. (Paul Chrystal)

*Right*: Illingworth Mausoleum
A detailed view of a sphinx flanking the right side of steps to the Illingworth Mausoleum in 2010. Alfred Illingworth (1827–1907) was the founder of Wheley Mills, which at one time was the largest spinning mill in Bradford. He was Liberal MP for Knaresborough from 1868 to 1874, and for Bradford from 1880 to 1895. (© Historic England Archive)

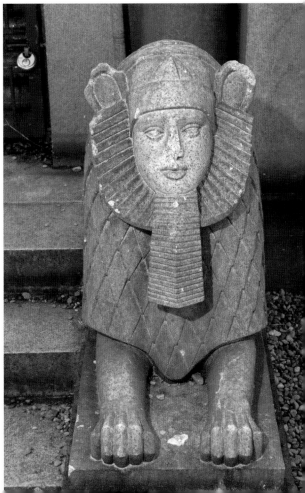

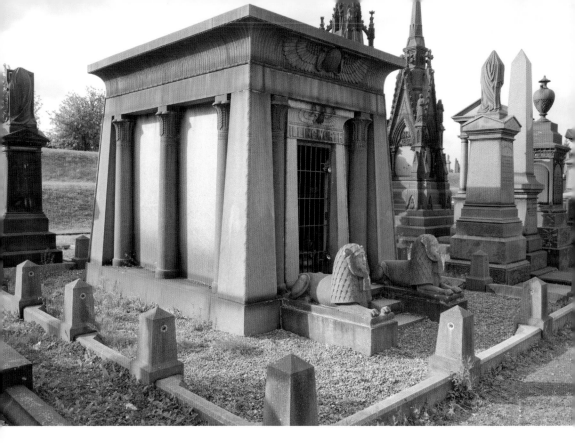

Illingworth Mausoleum
An exterior view showing the Illingworth Mausoleum in Undercliffe Cemetery, surrounded by other memorials. His mausoleum should more correctly be termed a columbarium as both he and his wife were cremated and their ashes were placed inside the building. (© Historic England Archive)

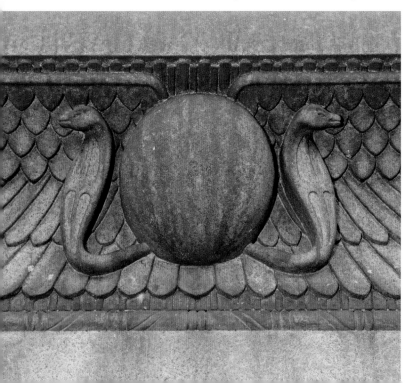

Illingworth Mausoleum
The Egyptian carving over the entrance of the Illingworth Mausoleum. The mausoleum was prefabricated at a quarry in Scotland and brought to Bradford by rail, sea and canal. It was then assembled by local stonemasons who carved the word 'ILLINGWORTH' above the door. The ornate bronze door was stolen some years ago. (© Historic England Archive)

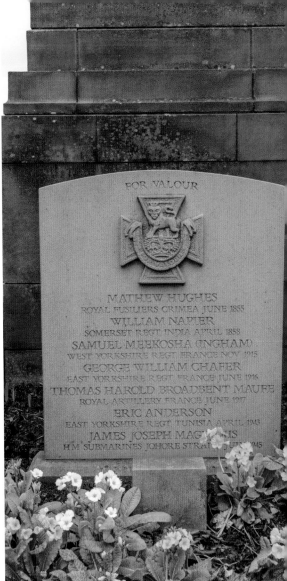

*Above left*: Burnley Family Obelisk

The prolific author James Burnley (1838–1919) was born in Shipley. He was living at Bowling by 1871 and Bramhope by 1891. He wrote a number of books on the local textile industry, including *History of Wool and Wool-Combing* (1891), *Phases of Bradford Life* (1871), *West Riding Sketches* (1873), *Yorkshire Stories Re-told* (1884), *Sir Titus Salt And George Moore* (1885), *Fortunes Made in Business* (1887) and *The Romance of Modern Industry* (1889). Burnley was Justice of the Peace for the borough of Bradford, a machine-wool comber and a woollen merchant. (© Historic England Archive)

*Above right*: Bradford War Memorial, Prince's Way

The memorial was unveiled on 1 July 1922, the sixth anniversary of the first day of the Battle of the Somme. Some 40,000 people attended the ecumenical ceremony. (© Historic England Archive)

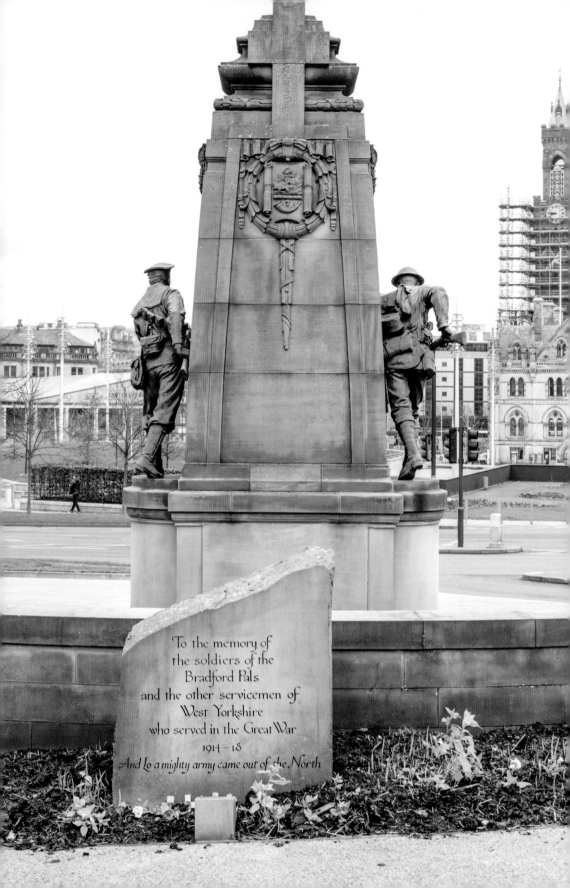

To the memory of
the soldiers of the
Bradford Pals
and the other servicemen of
West Yorkshire
who served in the Great War
1914 – 18
And Lo a mighty army came out of the North

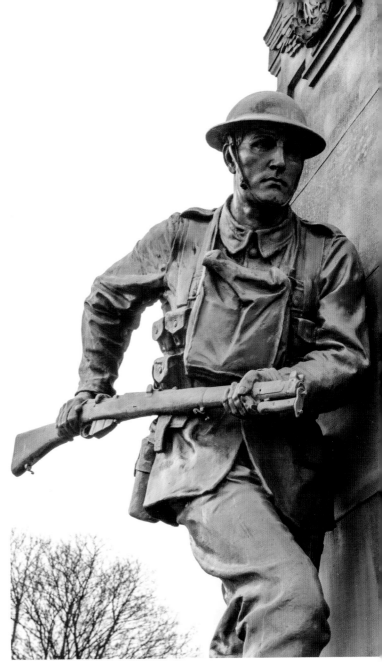

Detail of a Figure on Bradford War Memorial

Having served in the defence of the Suez Canal from late 1915, the 16th and 18th West Yorkshire Battalions sailed for France to fight in the Somme campaign as part of 93 Brigade in 31st Division. On the first day of the Battle of the Somme (1 July 1916) some 2,000 men of the Bradford Pals battalions were involved in the attack on Serre, which launched at 7.30 a.m. The two Bradford Pals battalions, attacking Pendant Copse, suffered heavy casualties – around 1,770 were killed or wounded. The reformed battalions continued serving in France, being disbanded in February 1918.

In total nearly 37,000 Bradford men served in the First World War, of whom around 5,000 were killed. (© Historic England Archive)

*Opposite:* Bradford War Memorial

The two battalions of the Prince of Wales's Own West Yorkshire Regiment were raised in Bradford in September 1914 (16th West Yorkshire, 1st Bradford Pals) and January 1915 (18th West Yorkshire, 2nd Bradford Pals). As 'pals battalions' they comprised men who had enlisted together with the promise that they would be able to serve alongside their friends, neighbours and work colleagues – 'pals' – rather than being allocated to battalions. These were two of the country's ninety-six Pals and City battalions. Local authorities provided the necessary clothing, billeting and food, while the army provided weapons and training. (© Historic England Archive)

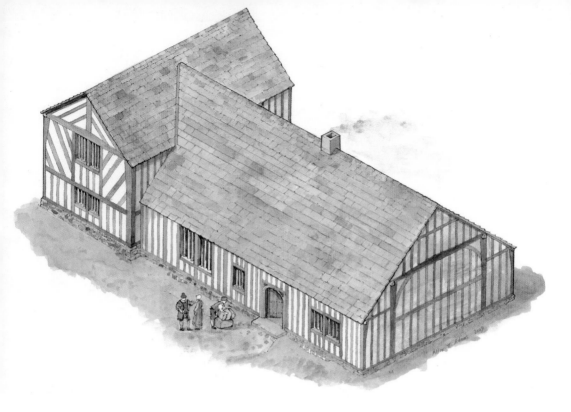

Old Manor House
A reconstruction drawing showing an oblique view of the Old Manor House, Rosebery Road, Manningham. This is how it may have appeared from the south-east in the early sixteenth century when it was fully timber framed. It is a fine West Riding Hall of a type more akin to the Halifax manor houses. The house was built by the Empsall family, who were yeomen of Wyke for over three centuries. The oldest part to the rear has the centre portion dated 1614 and was erected by E. Empsall. In 1694 the house was virtually doubled in size, with the extension work expanding towards the road. (© Historic England Archive)

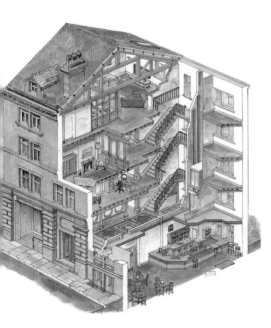

Warehouse Conversion
A cut-away illustration showing the possible options for converting a nineteenth-century warehouse in Bradford's Little Germany, including the creation of residential and commercial spaces in the building. (© Historic England Archive)

# Religious Buildings

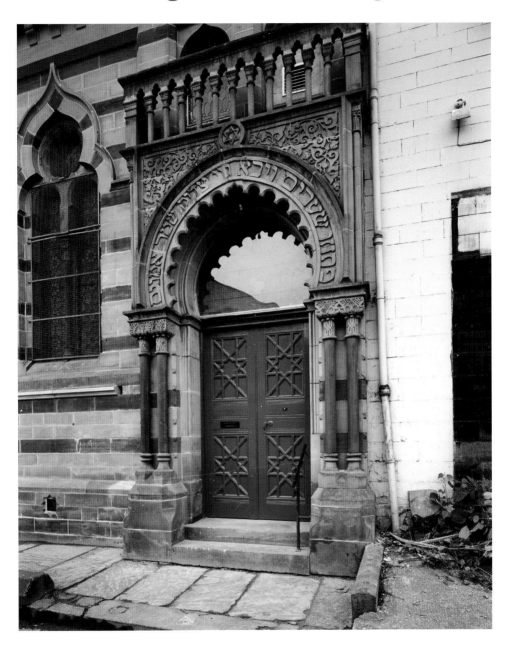

Entrance to Bradford Reform Synagogue
Bradford's synagogue is a very rare and well-preserved small-scale provincial synagogue. It is built in a coherent style throughout and is the best example in British synagogue architecture of the nineteenth-century fashion for 'Orientalism'. (© Historic England Archive)

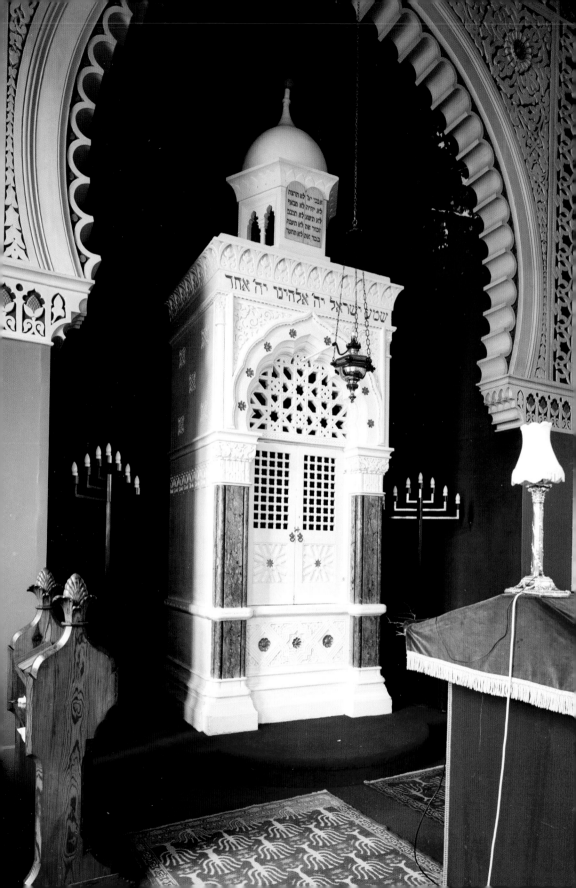

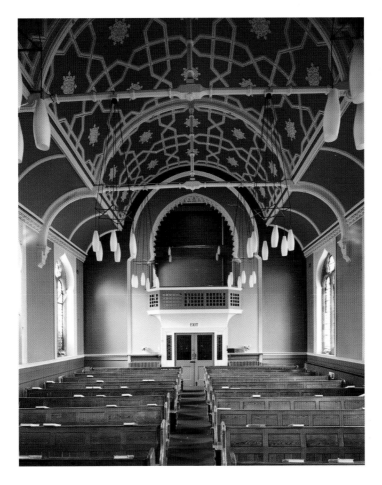

*Above, opposite and overleaf*: Bradford Reform Synagogue

Bradford's was the third Reform synagogue to be established in the United Kingdom and, uniquely, it predated the building of an Orthodox synagogue in the city. The foundation stone was laid in 1880. A recent decline in the local Jewish community led to financial difficulties, and a meeting was held in June 2009 where the community agreed to the sale of the building as 'a very last resort'. Funding was secured, supported by the local Muslim community, thus enabling people to continue using the current building.

'The oldest Reform synagogue outside London' was established by German Jews attracted to Bradford by the wool trade. In 1881 exiled Russian Jews made their home in Bradford and founded the Orthodox synagogue.

Jacob Moser (1839–1922), a Dane, was a founder of the Reform congregation and a passionate early Zionist who became mayor of Bradford. He supported the large poor Jewish community in Leeds at that time. Moser was one of the founders of the Bradford Charity Organisation Society and the City Guild of Help. He served on the board of the British Royal Infirmary from 1883 and contributed £5,000 to the local fund for the building of a new institution. He provided £10,000 in 1898 as a benevolent fund for the aged and infirm of the city, and supported the local children's hospital. He also donated 12,000 books to Bradford Central Library and was involved in Bradford Technical College, the Workers Educational Association and the Bradford Scientific Association. (© Historic England Archive)

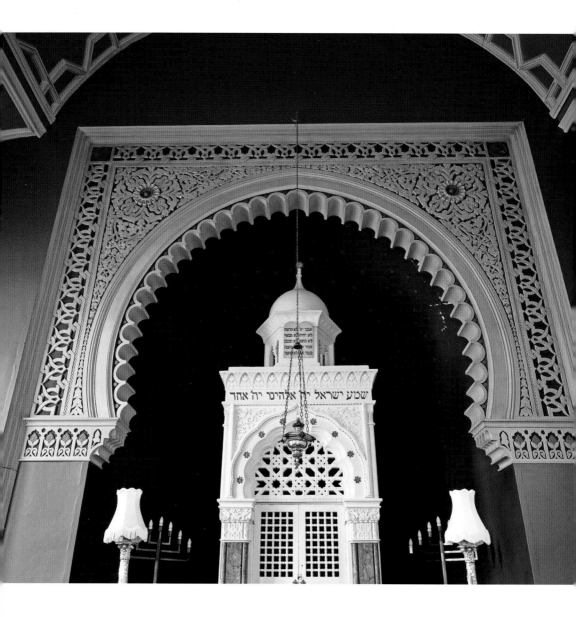

*Opposite above*: Bradford Cathedral

Bradford Cathedral (its full name being the Cathedral Church of St Peter and formerly Bradford Parish Church) is seen here in 1943 with its east window bricked up – the stained glass was removed to protect it from bombing raids. It is the oldest building in the city but can boast a twentieth-century extension. It stands on a site used for Christian worship since the eighth century. Two carved stones – parts of a Saxon preaching cross – were found on the site, suggesting that Christians may well have worshipped here since Paulinus of York came to the north of England in CE 627 to convert Northumbria. He preached in Dewsbury and it was from there that Bradford was first evangelised. (Historic England Archive)

*Right*: Martyrs' Window, Bradford Cathedral
Detailed view of a stained-glass window by Morris & Co. in the cathedral's north transept. The cathedral's website (bradfordcathedral.org) says of it:

> Originally inserted in the south wall at the eastern end of what is now the South Ambulatory, in 1864. This was part of a much larger window of martyrs and angels surrounding Christ. The rest of the glass is now in the North Ambulatory illuminated window, and the other four martyrs are in the west wall of the South Transept. The old window was dismantled for Sir Edward Maufe's 1960s design, refurbished in 1991 by York Glaziers Trust and repositioned in 1992. (© Historic England Archive)

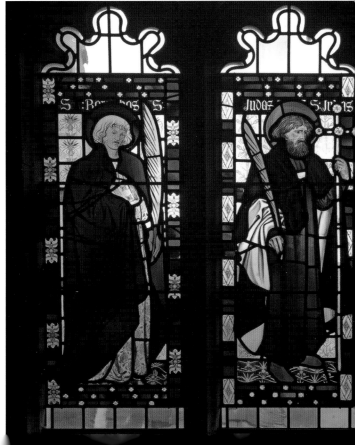

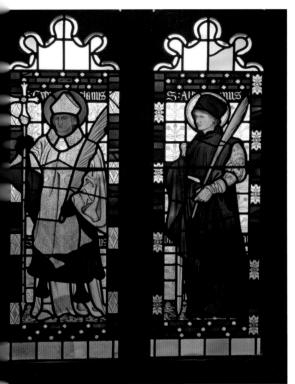 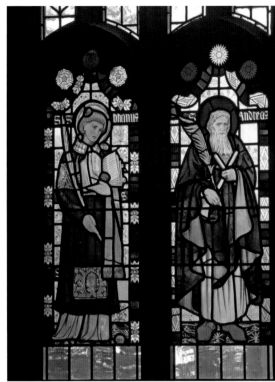

*Above, below and opposite above*: Stained-glass Windows, Bradford Cathedral
The cathedral was extended in the 1950s and 1960s by Edward Maufe. The east end of the cathedral is Maufe's work. As he reused the Morris & Co. stained glass from the old east window there is Victorian stained glass throughout the building, notably at the west end where there is a window showing the women of the Bible. (© Historic England Archive)

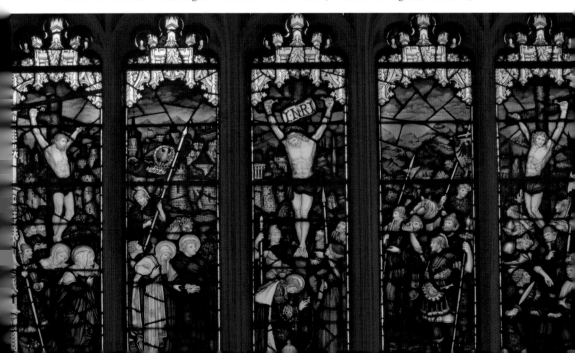

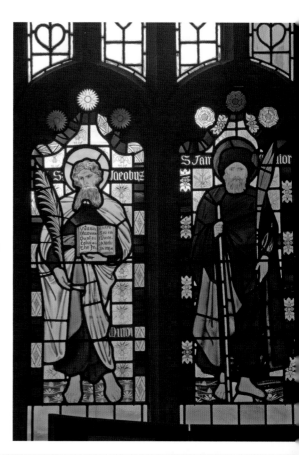

*Below*: Our Lady and the First Martyrs Roman Catholic Church

The First Martyrs of the Church of Rome were the first Christians persecuted in the city by Nero. The martyrs are celebrated by Roman Catholics on 30 June.

In July 64 CE Rome was devastated by a huge conflagration. The catastrophe was blamed on a fiddling Nero. He blamed the Christians. According to Tacitus, many Christians were put to death 'not so much of the crime of firing the city, as of hatred against mankind'. They were either covered with the skins of beasts, torn by dogs, nailed to crosses or burnt. Nero offered his gardens for the spectacle and exhibited a show in the circus while he mingled with the people. As a result, there arose a feeling of compassion even for perceived criminals. Peter and Paul were probably among Nero's victims. (© Historic England Archive)

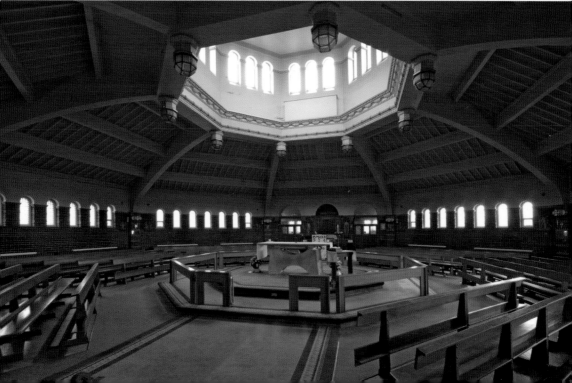

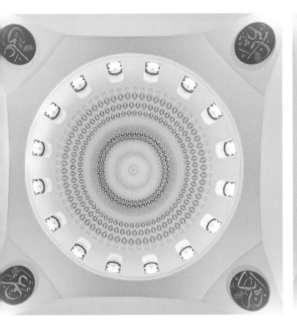

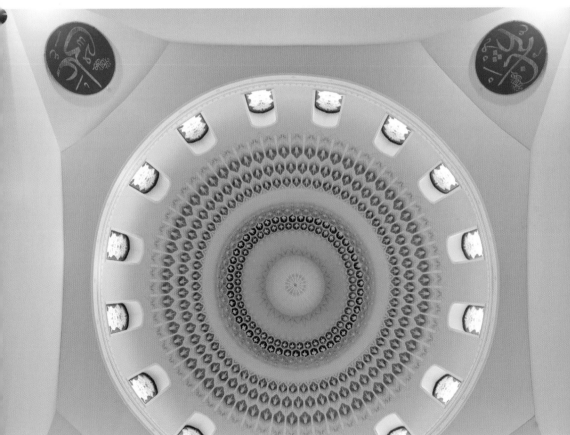

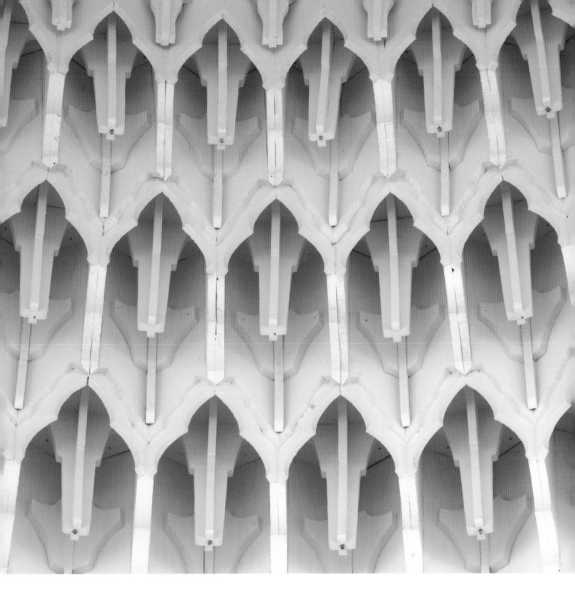

*Above*: Bradford Central Mosque
A detailed view of the decoration in the mosque's dome. (© Historic England Archive)

*Opposite*: Bradford Central Mosque
An interior view looking up into the beautifully decorated dome of Bradford Central Mosque. In 2015 there were around eighty-six mosques in Bradford. The mosque, the Jamia Masjid, was established in a terraced house in 1958, subsequently expanding into neighbouring properties as more space was required. The mosque is still in use today. (© Historic England Archive)

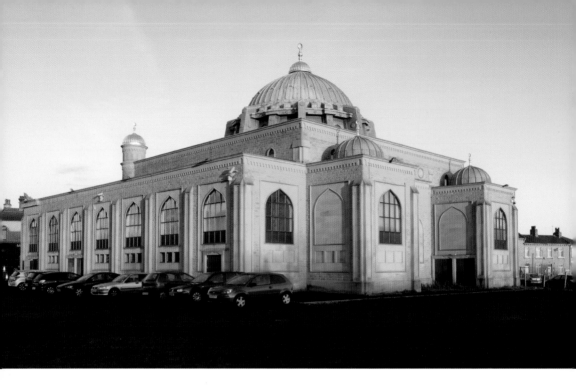

*Above*: Bradford Central Mosque
An exterior view of the mosque from the south-east. The building is constructed primarily of red Agra sandstone. (© Historic England Archive)

*Below*: Tawakkuliah Jami Masjid, Manningham
A view of the mosque from the north-east. (© Historic England Archive)

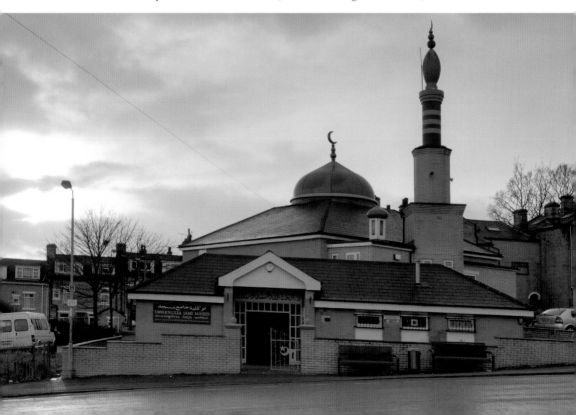

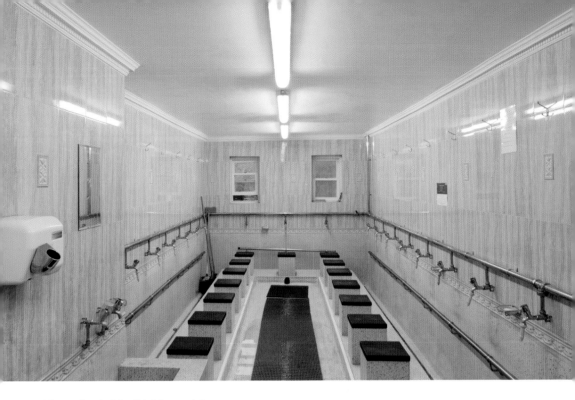

*Above*: Jamia Masjid, Howard Street
An interior view of the wudu or ritual purification ablution room on the ground floor of the mosque. (© Historic England Archive)

*Below*: Suffa-Tul-Islam Cental Masjid, Horton Park Avenue
An exterior view of Bradford Grand Mosque, along with detail of a turret beside the main entrance. (© Historic England Archive)

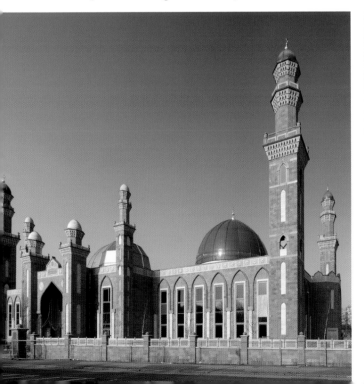

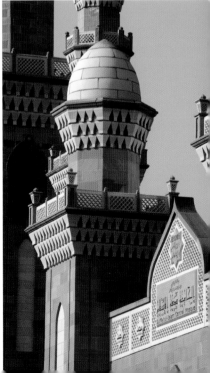

# Industry

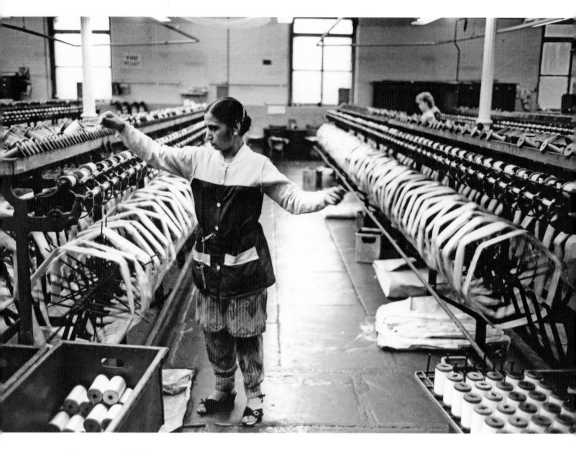

*Above*: Bradford Mills
At work in one of Bradford's mills. (Paul Chrystal)

*Opposite above*: High Mill
With its numerous mills, Bradford had a reputation of being one of Britain's most polluted towns. George Weerth, the radical German pamphlet writer and friend of Marx and Engels, worked in Bradford as a representative for a textile firm researching the impact of the Industrial Revolution on the relationship between property owners and workers. In 1846, in *Neue Rheinische Zeitung*, he described the town as follows:

> Every other factory town in England is a paradise in comparison to this hole. In Manchester the air lies like lead upon you; in Birmingham it is just as if you were sitting with your nose in a stove pipe; in Leeds you have to cough with the dust and the stink as if you had swallowed a pound of Cayenne pepper in one go – but you can put up with all that. In Bradford, however, you think you have been lodged with the devil incarnate. If anyone wants to feel how a poor sinner is tormented in Purgatory, let him travel to Bradford. (© Crown copyright. Historic England Archive)

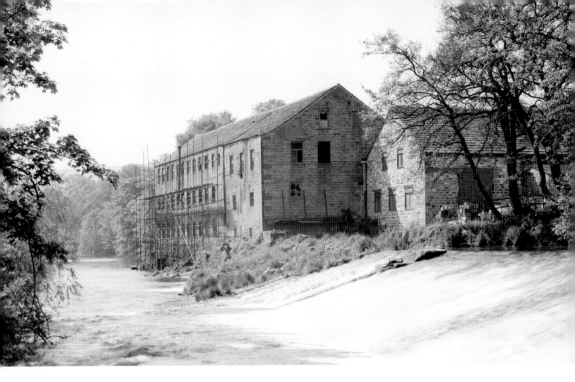

*Below*: Remains of the Mill Race at Ponden Mill, 1985

Ponden Mill was a three-storey, nine-bay, water-powered cotton mill that was built by Robert Heaton in 1791–92. It was repaired after a fire in 1795. The adjoining warehouse and cottage were added in the 1790s and later enlarged. An engine house and a boiler house were added in the 1850s and soon after the mill converted to worsted spinning. A new engine house was built in 1893. (© Crown copyright. Historic England Archive)

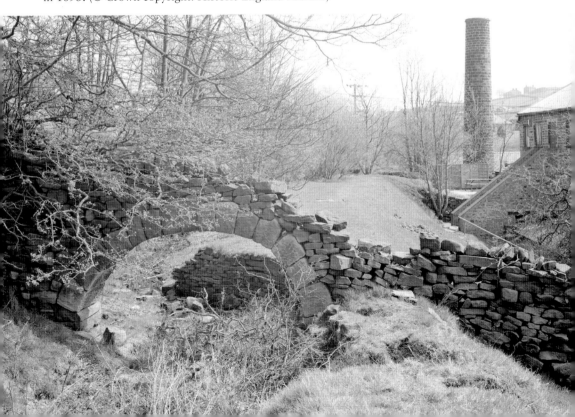

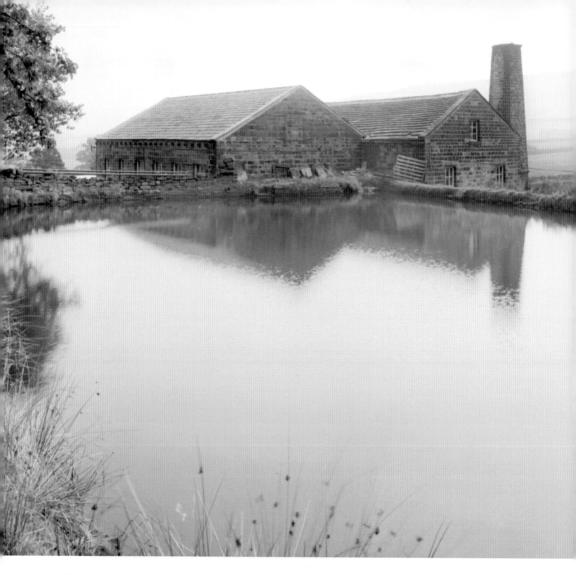

*Above*: Dunkirk Mill

This was a water-powered worsted mill that was established around 1800. The main building is a two-storey, eight-bay mill that is largely from *c.* 1870 but incorporates the remains of an early mill in the area of the wheelhouse. The complex is completed by cottages, a mill extension (used in the late nineteenth century for corn milling), remains of an added steam-power plant, and an extensive headrace and mill dam. The waterwheel was later replaced by a water turbine. (© Crown copyright. Historic England Archive)

*Opposite*: Lower Providence Mill

The mill is photographed here during demolition works in 1984. Established in the early nineteenth century as a water-powered worsted mill, it was rebuilt as a steam-powered mill in 1874–75. The earlier mill was incorporated into the later mill. It comprised four storeys and an attic, was thirteen bays long, was of a timber-floored construction and was powered by an internal end engine house. Later expansion involved the construction of a combing shed in 1895, a wool warehouse in 1897 and a warehouse and shed prior to 1908. (© Crown copyright. Historic England Archive)

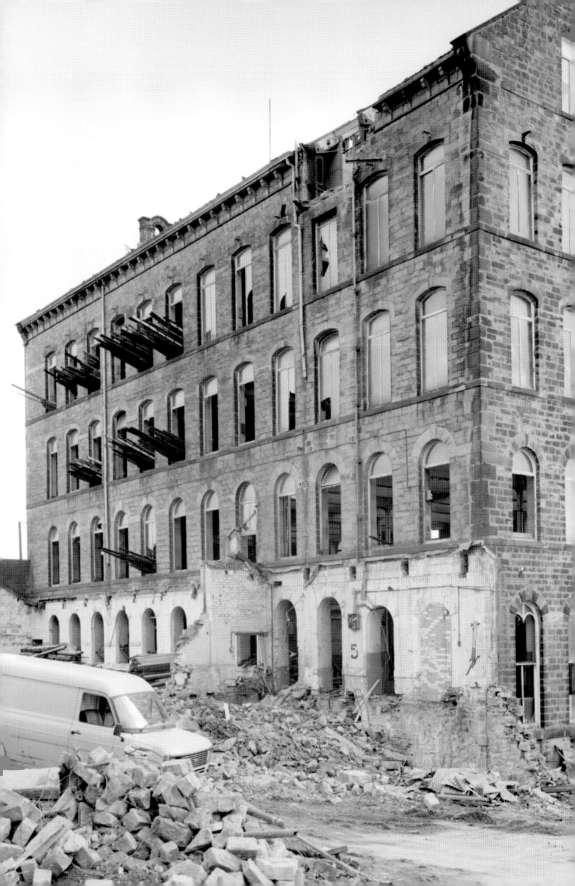

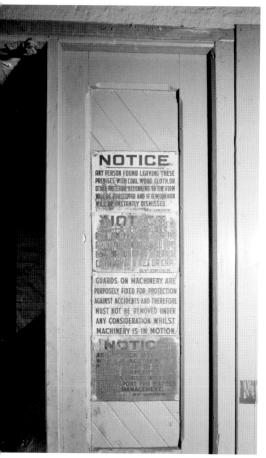 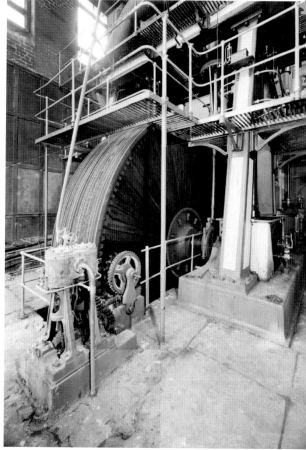

*Above left*: Lower Providence Mill
Some interesting notices can be seen attached to a doorway at this mill. (© Crown copyright. Historic England Archive)

*Above right*: Waterloo Mills
The interior of the engine house at Waterloo Mills, showing the rope drive in 1984. Waterloo Mills was a steam-powered worsted mill that was built *c.* 1870. By the early twentieth century it was run as a room and power mill. The main buildings include a four-storey, eighteen-bay timber-floored mill of *c.* 1870, large sheds of various dates, offices, warehouses and a 1916 engine house containing a 1905 inverted vertical engine that was bought second-hand. The original beam engine has been removed and its internal end engine house subdivided to give a rope race connecting with the new engine house. The roof of the mill was repaired with grant assistance from Historic England in 2016. (© Crown copyright. Historic England Archive)

*Opposite*: Waterloo Mills
A loom in the west shed of the mill. (© Crown copyright. Historic England Archive)

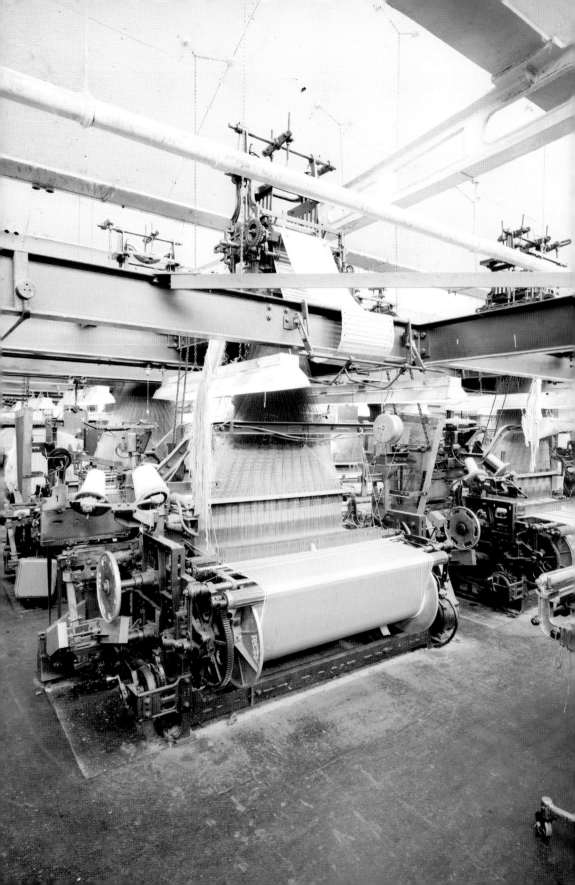

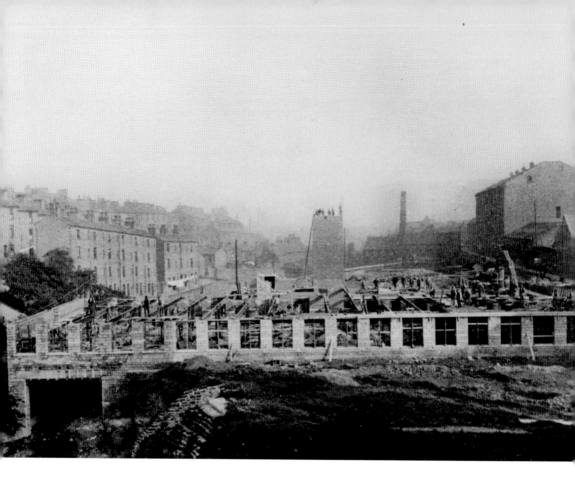

*Above*: Becks Mill, Silsden, Under Construction

Built in 1907 as part of the expansion of a long-established worsted spinning and manufacturing concern operating from Grove Mills in Keighley. The ambitious plans for two large mills and sheds by Moore and Crabtree of Keighley were not followed; instead, the 1907 complex took the form of a single large spinning mill of six storeys and eighteen bays with an attached boiler house and electricity-generating room. Becks is the earliest known example of a Yorkshire mill with its own generating plant. The mill is of a fireproof construction (using steel beams and hollow-brick floors) and has an angle iron shed roof. (© Crown copyright. Historic England Archive)

*Opposite*: Dalton Mills

The ground floor of the mill can be seen here with yarn-processing machinery on either side. Dalton was a large steam-powered worsted mill, which began in 1866 and expanded rapidly over the rest of the decade. The original scheme comprised three ornate mills: Tower Mill, which began in 1866 and had four storeys, an attic and nine bays; Genappe Mill, which began in 1868 and had three storeys and thirty-eight bays; and New Mill, which began in 1869 and had three storeys and thirty-three bays. The site also contained a long shed (work on which began in 1866), engine houses, boiler houses, a chimney and offices. The buildings are grouped around a narrow yard. The mill owners – I. & I. Craven – were worsted spinners and manufacturers, but it appears that Dalton Mills was used mainly for spinning. Later alterations included the 1904 addition of two horizontal engine houses, constructed to designs by John Haggas & Sons, necessitated by the accidental wrecking of the original pair of beam engines. (© Crown copyright. Historic England Archive)

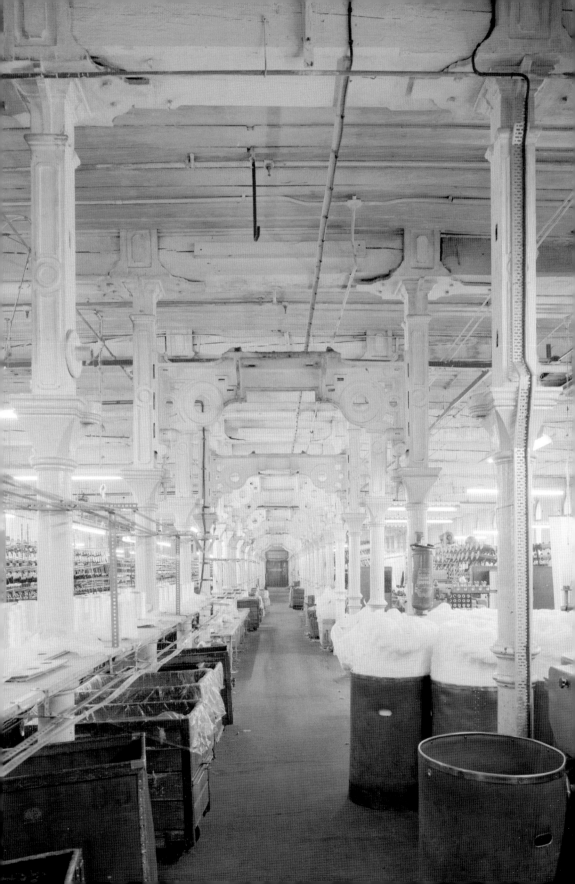

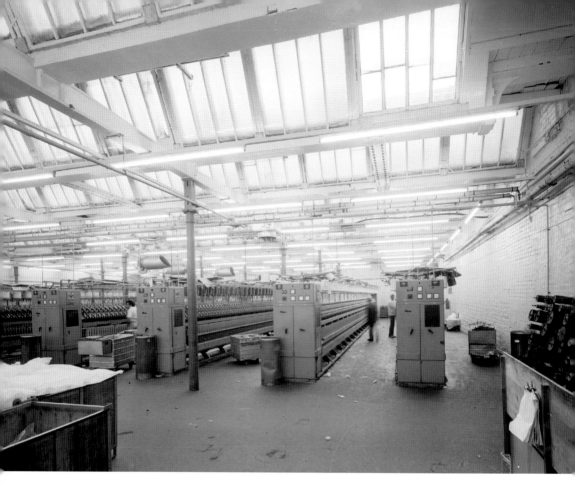

*Above*: A Spinning Shed at Whetley Mills

Whetley Mills was a steam-powered worsted mill built in 1863 to designs by Milnes & France of Bradford. It comprised a large warehouse, combing shed, engine house, spinning mill, yarn and waste warehouses, offices and a foreman's house, all of which were grouped around a small yard containing a boiler house and chimney. The main mill was five storeys (including a basement and attic) with nineteen bays of a fireproof construction. A single engine house provided power to the shed and mill – the latter had a drive transmitted by an upright shaft in a projecting shaft tower. There were later additions to combing sheds in 1871, 1883 and 1912, and a new power system and additions were made to the warehouses. Whetley is an important and architecturally impressive example of a large-scale worsted mill with its own combing capacity. (© Crown copyright. Historic England Archive)

*Opposite above*: Cumberland Works

The Cemetery Road end of the Cumberland Works in 1988. (© Crown copyright. Historic England Archive)

*Opposite below*: Cumberland Works

Wool being stored in the warehouse of the Cumberland Works. The opening of the Bradford Wool Exchange in 1867 powered the growth of worsted mills, cotton mills and wool-combing works throughout Bradford. The Cumberland Works made a significant contribution to industrial development in Manningham. They were a large wool-combing factory established in 1875 near to Four Lane Ends. (© Crown copyright. Historic England Archive)

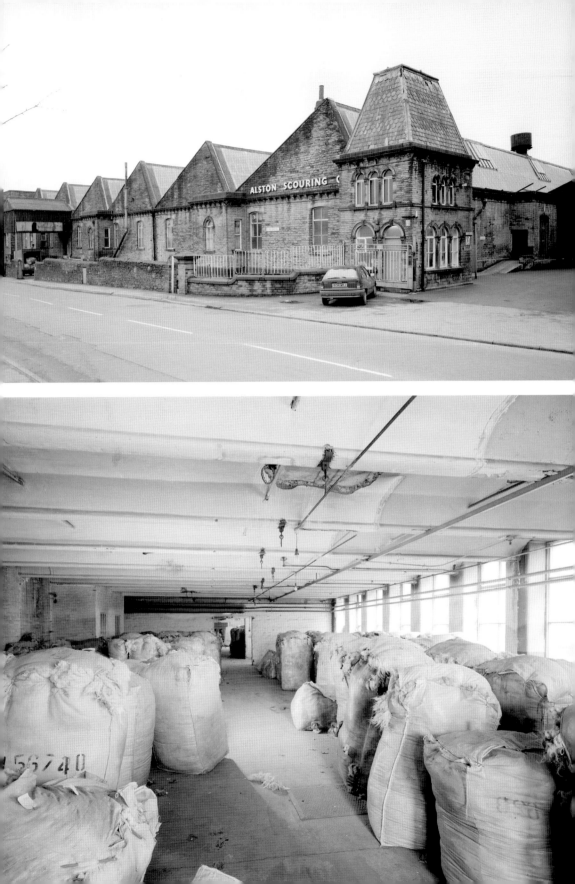

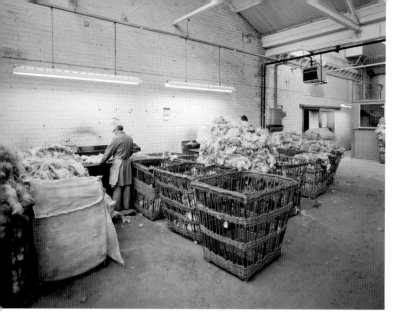

Wool Sorters
Wool sorters at work
in Cumberland Works.
(© Crown copyright.
Historic England Archive)

Dye Houses
Bradford textiles were formerly dyed in Wakefield or Leeds, but it was dyeing its own by 1797. By this time there were two dye houses working in the town: Bowling Dye Works and Peel's of Thornton Road. Dying was always a highly toxic process and remains so today. The image shows the dye house in Salt Mills in 1930, along with its toxic fumes and dyes – workers were exposed to these on a daily basis and had no masks or modern protective clothing. Dye fixatives were especially lethal, containing dioxin (a carcinogen), heavy metals such as chrome, copper and zinc (also carcinogens), and formaldehyde. (Paul Chrystal)

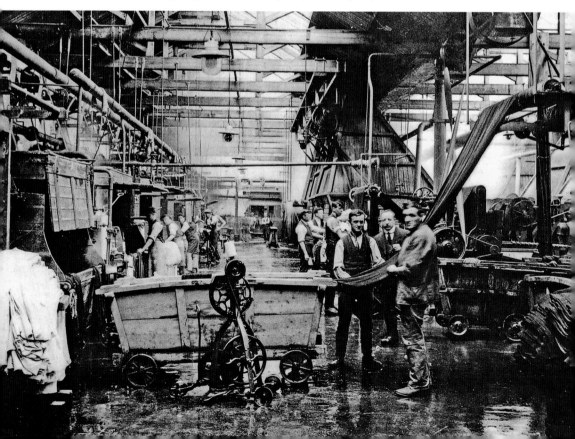

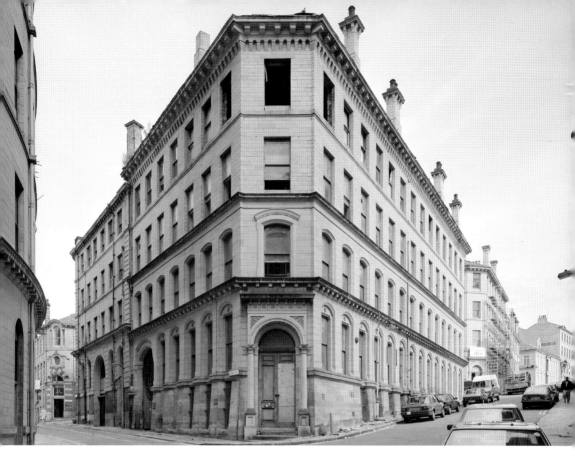

Looking North from Burnett Street towards Priestley's Warehouse, Vicar Lane, 1988
Historic England says: 'This elaborate building was constructed in 1867 as a wool warehouse, although with its neo-classical pretensions it shares many similarities with Victorian civic architecture. It typifies the style of warehouse and office buildings located in the Little Germany area of the city.' (© Crown copyright. Historic England Archive)

Priestley's Warehouse, Nos 66–70
Vicar Lane
The wrought-iron gates of Priestley's
Warehouse. (© Historic England Archive)

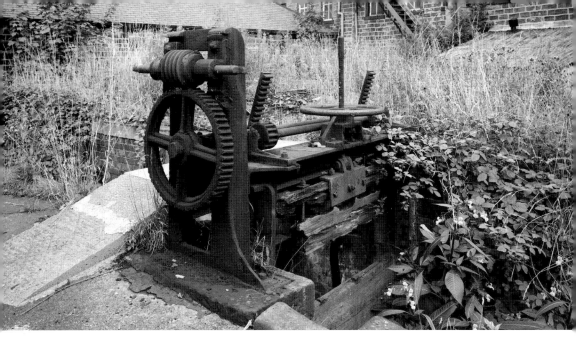

*Above*: Sluice Mechanism at Low Mill, Keighley

The original mill building was begun in the late eighteenth century by the Ramsdens of Halifax and completed by Clayton & Walshman, who began cotton spinning in June 1780. The machinery was made under the direction of Sir Richard Arkwright. Since the cotton-spinning process was new to this area a number of employers were sent to Arkwright's Works at Cromford, Derbyshire, to master the techniques involved. In the nineteenth century the mill was converted to worsted. (© Crown copyright. Historic England Archive)

*Below*: Manningham Mills

The interior of the boiler house at Manningham Mills. (© Crown copyright. Historic England Archive)

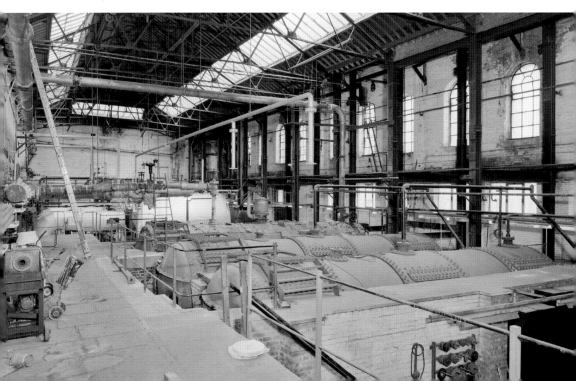

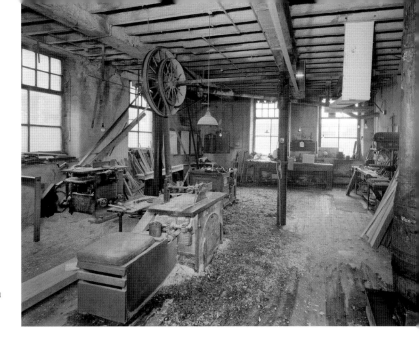

Soho Mills
The interior of the sawmill workshop at Soho Mills. (© Crown copyright. Historic England Archive)

Millman Swing Bridge
The Leeds and Liverpool Canal links the cities of Leeds and Liverpool via Bradford. It is 127 miles long, crosses the Pennines and includes ninety-one locks on the main line. It was first used in 1784 and results from the burgeoning mid-eighteenth-century industrial towns of Yorkshire including Leeds, Wakefield and Bradford. While Aire & Calder Navigation served the east for Leeds, links to the west were limited. Bradford merchants wanted to increase the supply of limestone to make lime for mortar and agriculture using coal from Bradford's collieries and to transport textiles to Liverpool. (© Crown copyright. Historic England Archive)

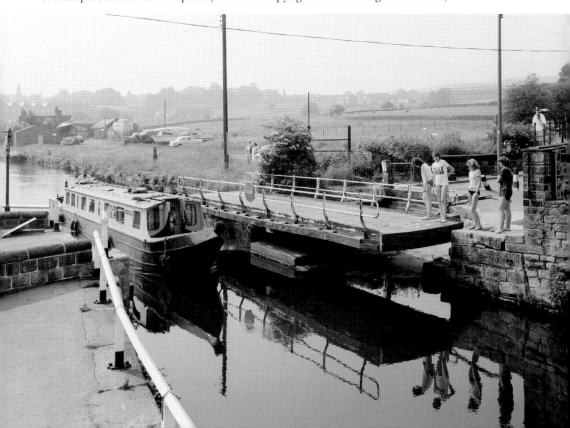

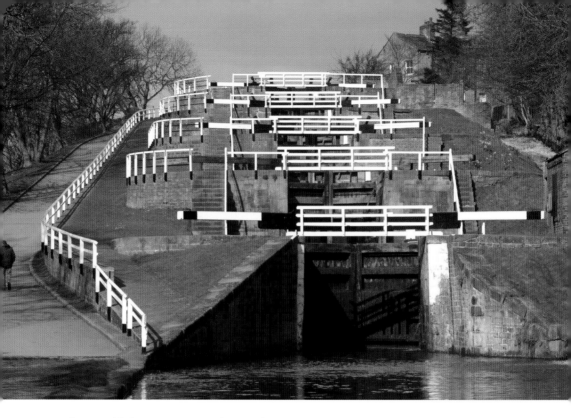

*Above and below*: Five Rise Locks, Bingley
Seen here from the south on the Leeds and Liverpool Canal in 2007. (© Historic England Archive)

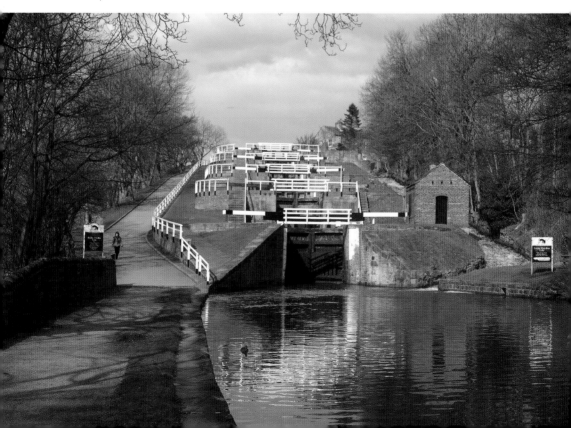

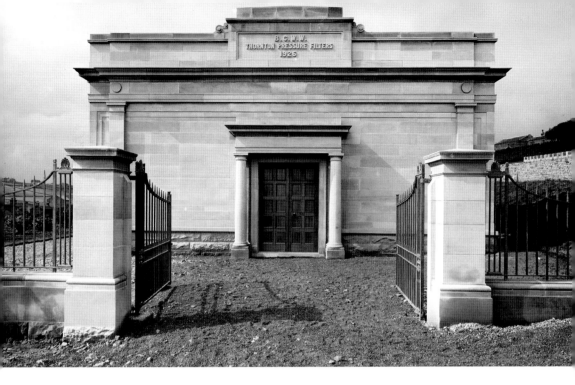

Thornton Pressure Filters
*Above*: The magnificent front entrance and gate at Thornton Pressure Filters in 1926. Bradford County Water Works (BCWW), Thornton Pressure Filters, was built in 1926 to serve the villages of Denholm and Thornton. It closed in around 1975. (Historic England Archive)

*Below*: The interior of the filter house at Thornton Pressure Filters. (Historic England Archive)

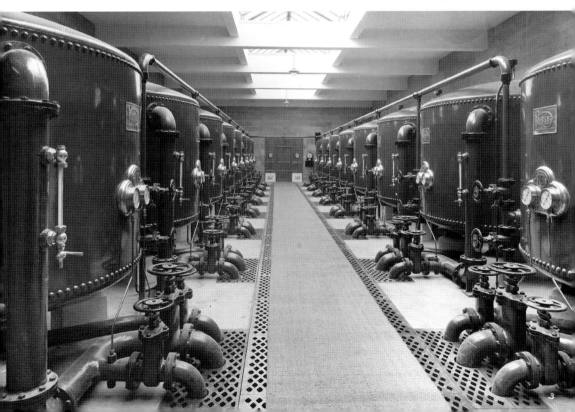

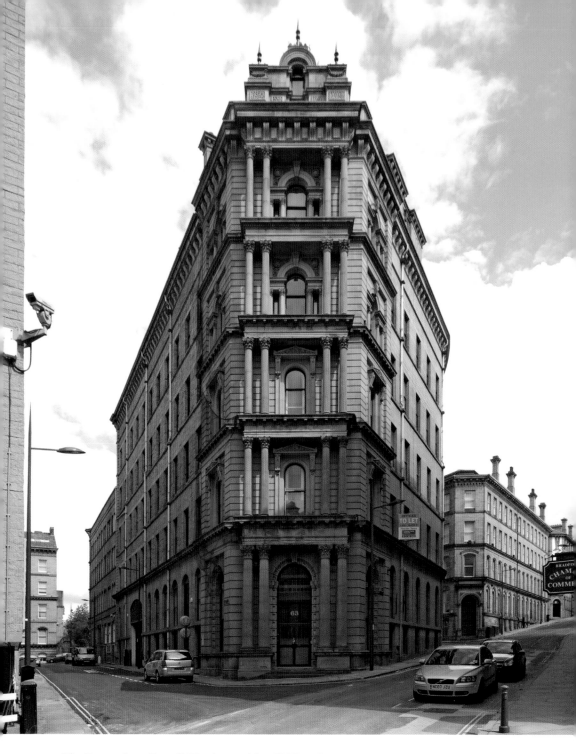

The Former Law Russell Warehouse, No. 63 Vicar Lane
Law Russell was a warehouse designed and built in 1873 by Lockwood & Mawson. (© Historic England Archive)

Paraphernalia
Some of the wonderful cotton industry paraphernalia on display in the Bird in Hand pub in Stockport. 'Cotton in Lancashire; wool in Yorkshire', or so the old adage goes. After 1835 it is quite true that wool was the Yorkshire textile of choice, but before that cotton mills were very much in evidence – their spinning machines later switched from cotton to wool. Towns like Keighley and Todmorden owe their expansion to cotton. Bradford, too, had its share of cotton mills; for example, Knight's Mill, Holme Mill and Rand's Mill. This is less of a surprise when we consider that more than 40 per cent of the country's cotton workers in the late eighteenth and nineteenth centuries were employed outside of Lancashire – the county best-known for the industry – in fifteen other counties of England and Wales. (Paul Chrystal)

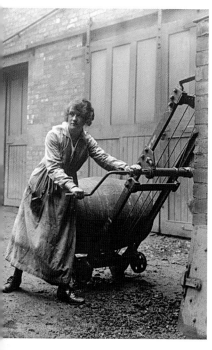

*Left*: Bowling Iron Works
A female worker demonstrates a barrel-lifting device at the Bowling Iron Works in November 1918. (Courtesy of the Imperial War Museum)

Ironworks at Low Moor and Bowling mark the birth of Bradford as an industrial town from the end of the eighteenth century. They brought with them not just prosperity and employment but also dramatic population growth and pollution. The Bradford 'iron age' overlapped with the 'textile age', in which numerous mills were constructed to produce copious amounts of worsted wool products, elevating the town to the status of wool capital of the world.

The Bowling Iron Works was established around 1780 in East Bowling, to the south-east of central Bradford. Bowling township lay above the Yorkshire coalfield where deposits of black bed and better bed coal were prolific in the eighteenth and nineteenth centuries, which were good for coke. There were also substantial deposits of limestone. All of these deposits were near the surface, facilitating extraction. The Bowling Iron Works operation included mining coal and iron ore, smelting, refining, casting and forging. The company turned out shackles, hooks and piston rods for locomotives, colliery cages and other mining appliances where tough iron was a prerequisite. (Paul Chrystal)

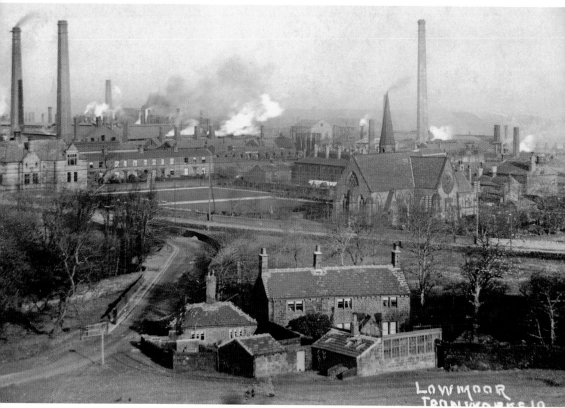

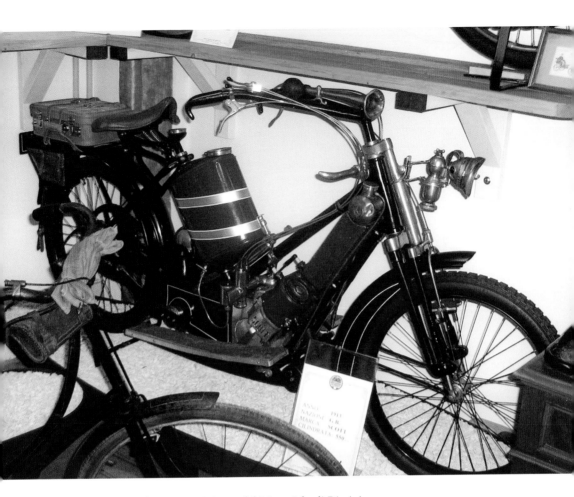

*Above*: A Scott 550 from 1913, Museo del Motociclo di Rimini
The Scott Motorcycle Co. was founded by Alfred Angas Scott in 1908 as the Scott Engineering Co. and was owned by Scott Motors (Saltaire) Ltd, Shipley. The first few machines were produced by Jowett in 1908. Not long after this he set up as a manufacturer at the Mornington Works, Grosvenor Road, Bradford. Scott's machines were top of the range, cutting edge and marketed as a 'wheeled horse for the Edwardian Gentleman'. Scott motorcycles were so powerful that they often easily beat four-stroke motorcycles of the same capacity. (Paul Chrystal)

*Opposite below*: Low Moor Company
The Low Moor Company employed 1,500 men in 1929. With it, over time, came the essential infrastructure and amenities necessary to support a mushrooming population, such as housing, churches, shops, pubs and public buildings. At one time it was the largest ironworks in Yorkshire, with a major complex of mines, mountains of coal and ore, kilns, blast furnaces, forges and slag heaps all connected by a network of railway lines. All of this, of course, created waste and toxic smoke from the furnaces and kilns blotted out the sun. In 1829 local poet John Nicholson captured the industrial landscape in verse: 'When first the shapeless sable ore Is laid in heaps around Low Moor, The roaring blast, the quiv'ring flame, Give to the mass another name: White as the sun the metal runs, For horse-shoe nails, or thund'ring guns ... No pen can write, no mind can soar To tell the wonders of Low Moor.' (John Nicholson, 'Low Moor Iron Works', 1876) (Paul Chrystal)

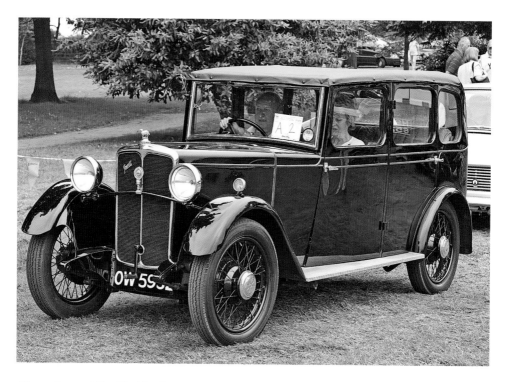

*Above*: Jowett 7 hp Blackbird, 1932

The Jowett Motor Co. was a prestigious motor car company that operated from Bradford in 1901–54, thus spanning the golden age of British motor car production. The company was founded in 1901 by two brothers, Benjamin (1877–1963) and William (1880–1965) Jowett, together with Arthur V. Lamb. In the very early days the company focused on transport of the two-wheeled variety, taking advantage of the contemporary craze for bicycles and cycling. In 1904 the name changed to the Jowett Motor Manufacturing Co. and was based in Back Burlington Street. The first Jowett light car prototype came off the production line in February 1906; however, after more than 25,000 miles of exhaustive trials, the inaugural model did not go into production until 1910 as the workshop was already busy with general engineering work, experiments with different engine configurations and manufacturing the first six Scott motorbikes. The mission was to offer a low-weight vehicle at a modest price with low running costs – in effect, the United Kingdom's first real light car. (Paul Chrystal)

*Opposite above*: A Lister Comb

This was manufactured by John Perry, Shipley, in 1888. (Paul Chrystal)

*Opposite below*: Bradford Industrial Museum

Moorside Mill opened in 1875 and grew into a medium-sized factory, employing around 100 workers, focusing on worsted yarn for weaving. Originally powered by steam engines, Moorside Mills was converted to electricity in the early twentieth century. The business grew significantly during the First World War when worsted was needed in prodigious quantities for military uniforms. The mill's working life ended in 1970. Bradford Corporation bought Moorside Mill and housed an industrial museum there to preserve Bradford's industrial heritage.

The image shows a spinning machine at Bradford Industrial Museum – a Noble Comb. (Courtesy of Linda Spashett)

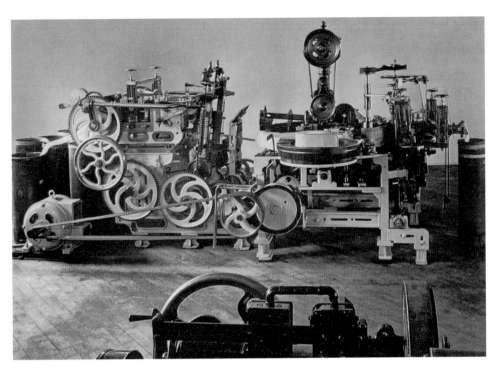

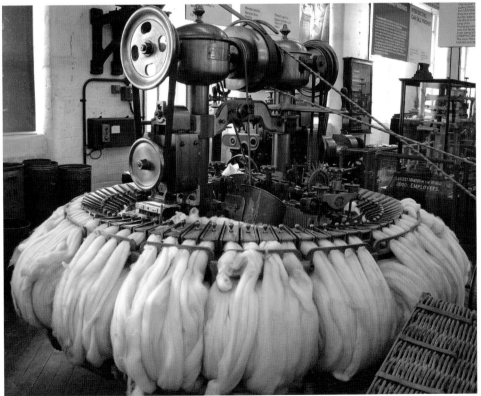

# Business

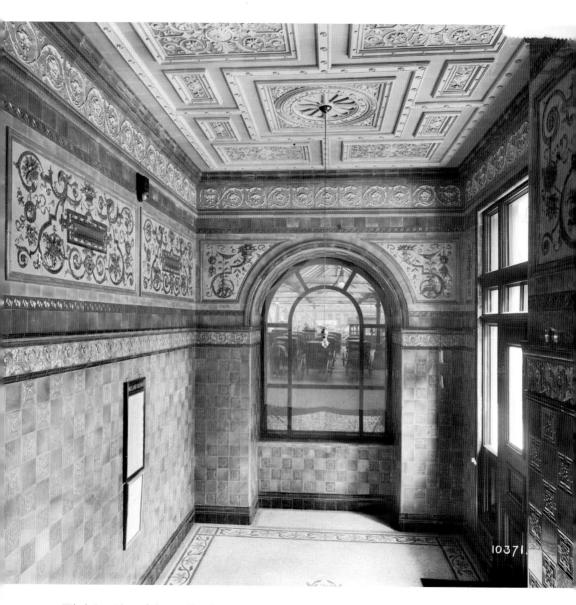

Tiled Corridor of the Midland Hotel's Restaurant
The building of the hotel began in 1885 and took five years to complete. It was built by the Midland Railway Co. as part of the original Forster Square railway station and as a showpiece for the company's northern operations. It later fell into disrepair, but was bought by Bradford entrepreneur John Pennington in 1992 who restored it, with the hotel reopening as the Pennington Midland Hotel in 1993. It was sold to Peel Hotels in 1998, who rebadged it with its original name. (Historic England Archive)

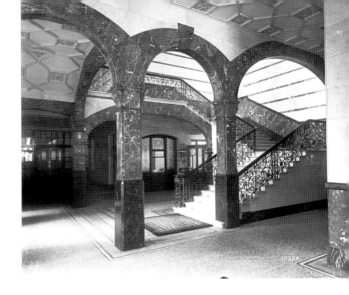

**Midland Hotel**
The entrance hall at the Midland
Hotel, looking towards the staircase.
Sir Henry Irving died here in 1905.
(Historic England Archive)

**Yorkshire Penny Bank Telling Hall, 1890**
The Yorkshire Penny Bank was established on 1 May 1859 by Colonel Edward Akroyd in
Halifax. Registered under the Friendly Societies Act, individual deposits were restricted to £30
per annum, up to a cumulative balance of £150. Within a year the bank had opened twenty-
four branches, and a further 104 the year after. The bank operated on a non-profit basis and in
1860 it was decided to expand into the other Ridings of Yorkshire. In recognition of this, the
name was changed to the Yorkshire Penny Bank. In 1872 it issued chequebooks for the first
time, focusing on small tradesmen. Sub-branches were opened in schools and church halls when
the bank became the first to create school banks – to encourage the idea of saving at an early
age. (Historic England Archive)

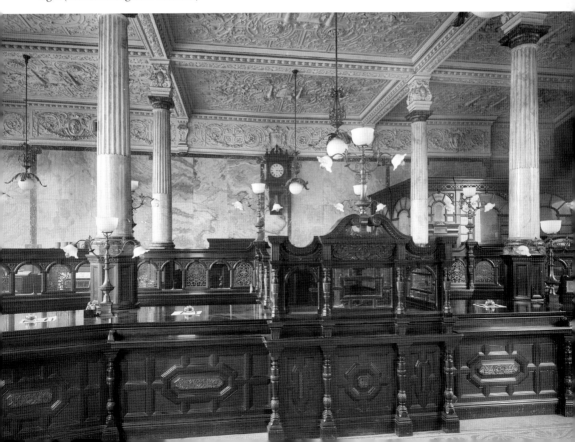

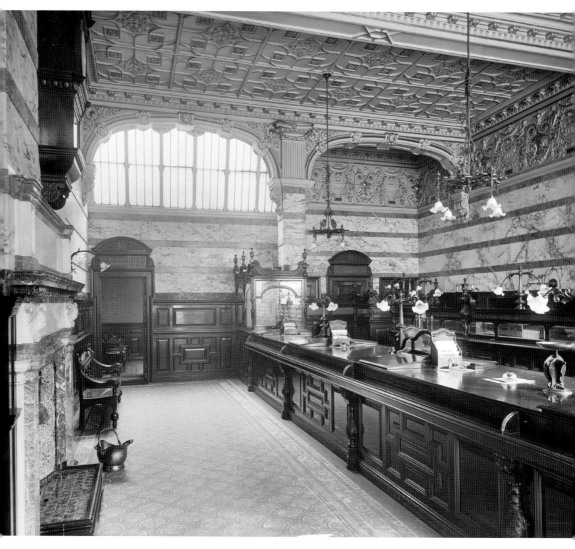

Banking Counter of the London City and Midland Bank, 1890
The bank was founded as the Birmingham and Midland Bank in Birmingham in 1836. It expanded in the Midlands, absorbing many local banks, and merged with the Central Bank of London Ltd in 1891, becoming the London City and Midland Bank. After a period of nationwide expansion the name Midland Bank Ltd was adopted in 1923. By 1934 it was the largest deposit bank in the world. In 1992 it was taken over by HSBC Holdings plc, who phased out the Midland Bank name in 1999 in favour of HSBC Bank. (Historic England Archive)

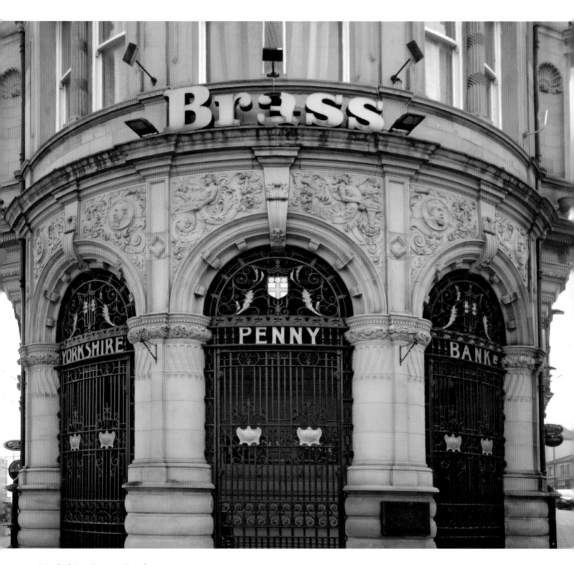

Yorkshire Penny Bank
The decorated façade of the former bank in 2007, showing that it was subsequently used as a
pub. (© Historic England Archive)

*Above*: *Telegraph & Argus* Building

The *Telegraph & Argus* is Bradford's daily newspaper and is now printed early morning in Oldham six times a week. *The Argus Weekly* was based in Argus Chambers in Britannia House over a century ago. *The Yorkshire Evening Argus* and the *Bradford Daily Telegraph* newspapers later merged to form the *Bradford Telegraph & Argus*, which has occupied its present building, the former Milligan & Forbes Warehouse, for decades. 'Bradford' was dropped from the title in the 1930s, when the paper's circulation area spread across much of West Yorkshire. At one time it had branches in nine towns across the region as well as an office in Morecambe, the retirement seaside town of choice for many Bradford people. At its height the paper's daily sales exceeded 130,000. The glass curtain wall was added in the 1980s to house the printing press, which presented an impressive sight to passers-by at night when the interior was illumintaed and the press was on. (© Historic England Archive)

*Opposite*: Busbys, Manningham Lane

*Above*: Busbys was founded by Ernest Busby on Kirkgate in 1908. They originally employed forty staff, but by the 1950s the store was keeping 830 staff in work. Busbys closed their Kirkgate store on Easter Sunday in 1930 to make the big move to Manningham Lane. The building exuded Victorian Gothic, and the logo – four marching and helmeted Coldstream guards – became a badge of Bradford itself. The popular bargain basement rubbed shoulders with the showrooms full of luxury gowns and dresses... and furs. Ernest Busby was himself a furrier and bought in skins from Leipzig even before the First World War. One mink coat sold for £4,600. Debenhams bought the business in August 1958, and this store closed in 1978. (Paul Chrystal)

*Below*: The Busby Nail Bar in the 1960s. (Paul Chrystal)

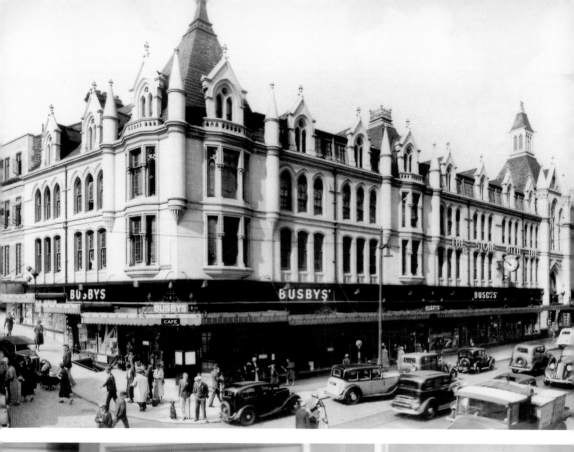

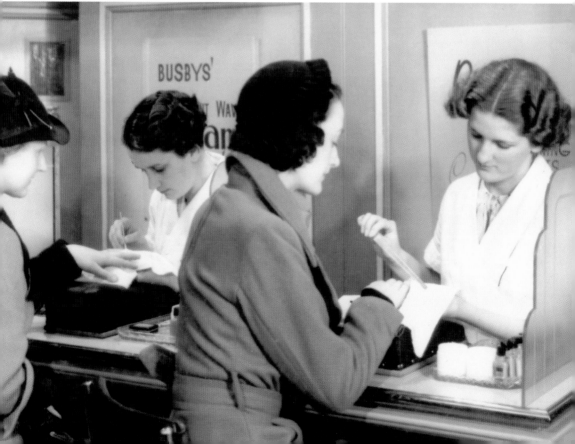

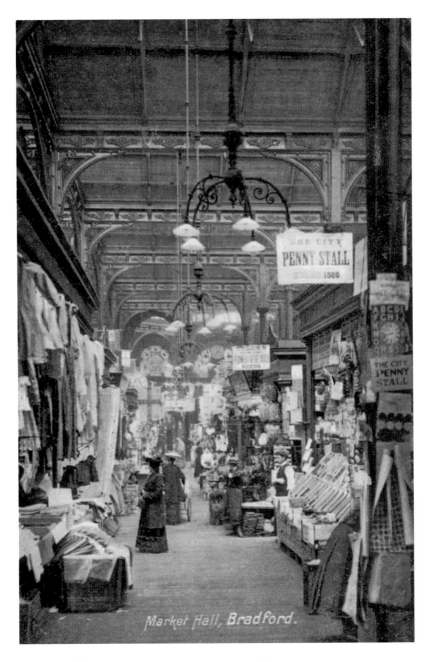

Market Hall
The famous Bradford chain of chemists was run by Whitworth Rimmington (1873–1926). His uncle, Felix Marsh Rimmington, was a respected and eminent chemist. In 1858 Felix Marsh was called as a professional witness in a celebrated arsenic poisoning trial, uncovering the mystery of the humbug sweets poisoning – the accidental arsenic poisoning of more than 200 people from sweets sold from a market stall in Bradford. (Paul Chrystal)

# Schools and Universities

Thackley Open Air School

Between 1908 and 1939 poorly children from Bradford were bussed into the Open Air School in Buck Wood. Bradford still had many areas of slum housing with overcrowded, damp and insanitary homes close to the woollen mills. Many of the children who lived in these poorest slums were unhealthy because of overcrowding, pollution and bad sanitation. Thackley offered some relief and recuperation from respiratory and infectious diseases. (Historic England Archive)

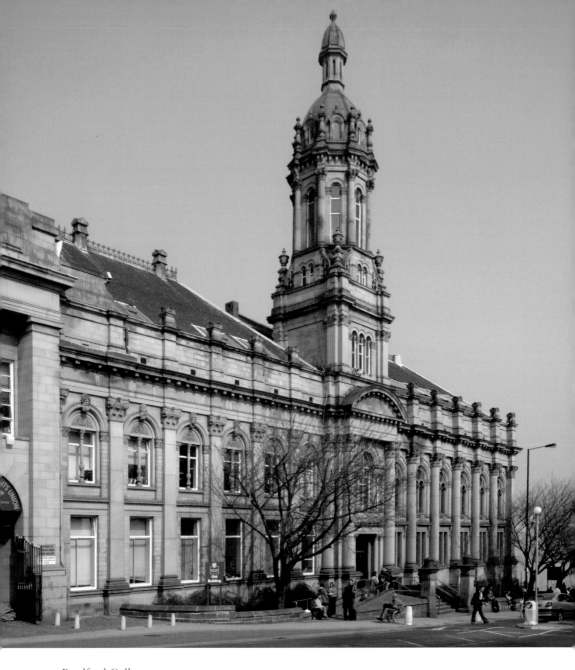

Bradford College

Bradford College has approximately 25,000 students enrolled. It has its origins in 1832 with the Bradford Mechanics' Institute. By 1863 the institute had its own School of Industrial Design and Art. On 23 June 1882, the then Prince and Princess of Wales (later Edward VII and Queen Alexandra) opened the new school to much celebration: 'From Saltaire Station to the Technical School, a distance of four miles, was one continuous avenue of Venetian masts, streamers, and many coloured banners, while at appropriate points triumphal arches of great magnificence were erected.'

In 1982 the institution was named the Bradford and Ilkley Community College after a merger with Ilkley College. This was closed in 1999 and soon after the institution was renamed Bradford College. (© Historic England Archive)

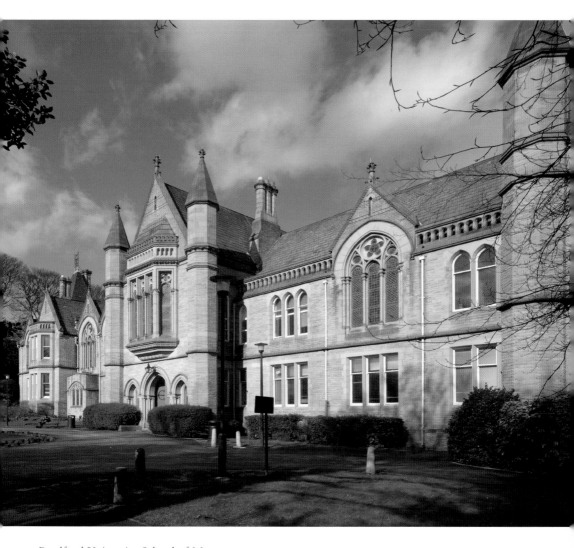

Bradford University School of Management
The Bradford Universtiy School of Management was established in 1963 and is located near Lister Park, separate from the main University of Bradford campus. The school is one of the UK's pre-eminent management schools. More than thirty nations are represented at the Bradford campus. Over 60 per cent of students and over 50 per cent of the faculty come from outside the UK. (© Historic England Archive)

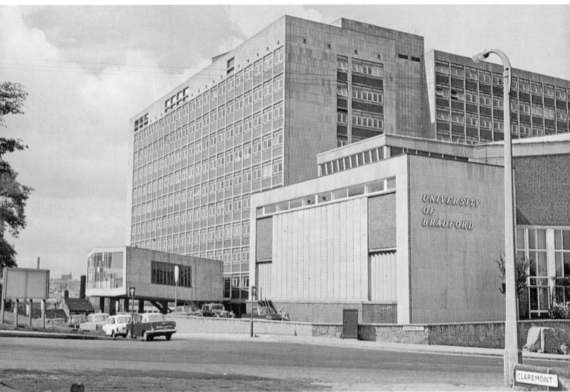

The University, Bradford

B.26

Bradford Technical College

The Bradford Technical College (1882–1956) was established to cater for the educational needs of the workers of the city's textile industries. It developed into what is now the University of Bradford. The University of Bradford's origins go back to the Mechanics' Institute, which became the Bradford Technical College in 1882. In 1957 the Bradford Institute of Technology was formed as a College of Advanced Technology. To a large extent the university's courses and faculties reflect and promote the town's industrial heritage and provide a platform for future research and industrial development. The university inherited several engineering courses from the Bradford Institute of Technology, such as Civil Engineering, which is still taught today. The EIMC department was founded in 1991 and developed its courses in conjunction with the School of Art, Design & Textiles at Bradford and Ilkley Community College (now known as Bradford College) and the National Museum of Photography, Film and Television (now the National Media Museum). (Paul Chrystal)

# Parks

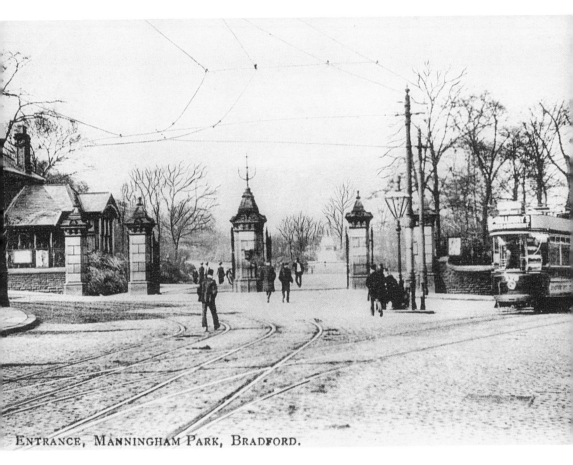

ENTRANCE, MANNINGHAM PARK, BRADFORD.

Manningham Park
Manningham Park is also known as Lister Park. It was donated to the City of Bradford by Samuel Cunliffe Lister, the man who built Lister's Mill. (Paul Chrystal)

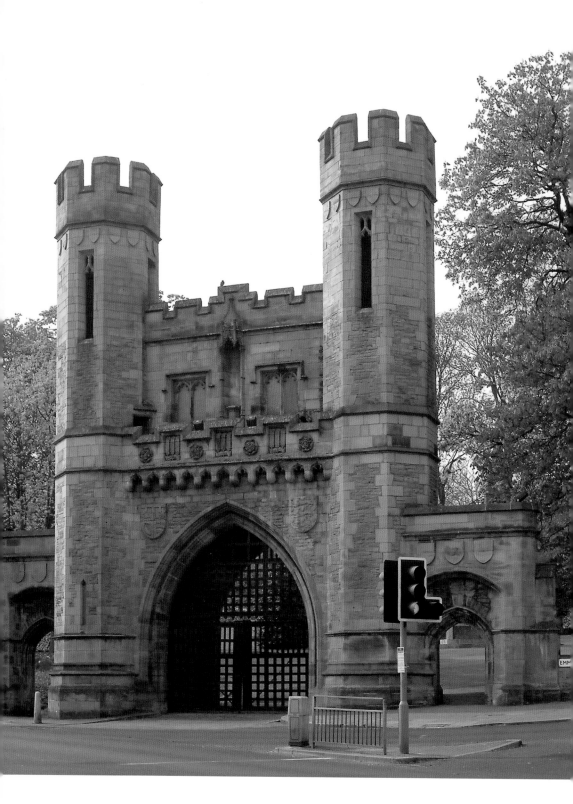

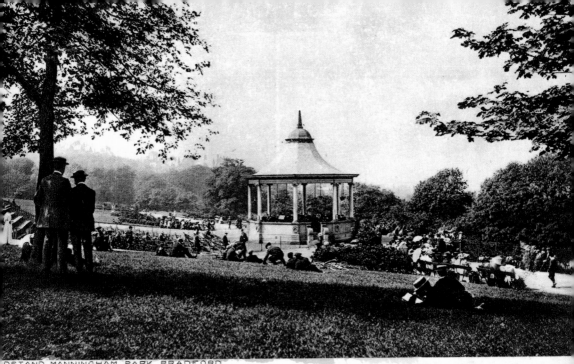

OSTAND, MANNINGHAM PARK, BRADFORD

Lister Park

*Opposite*: Gateway at the north end of Lister Park, Manningham. (© Historic England Archive)

*Above*: Looking towards the Lister/Manningham Park bandstand during a concert in around 1902. (Historic England Archive)

*Below*: The gates at the Princes entrance to Lister Park around 1902. (Historic England Archive)

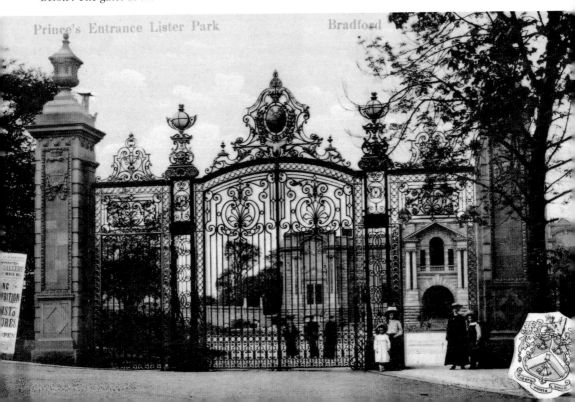

Prince's Entrance Lister Park          Bradford

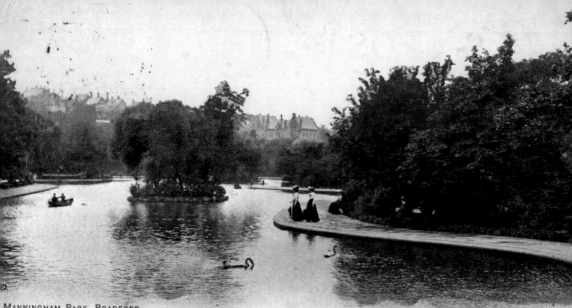

MANNINGHAM PARK, BRADFORD.

*How are you getting on Eh? Love Ma*

D. WILSON, Bradf

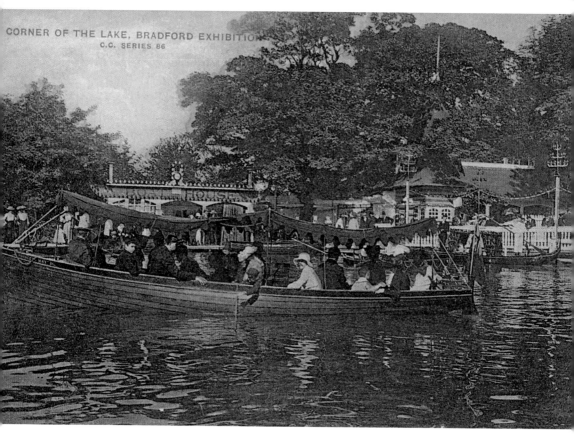

CORNER OF THE LAKE, BRADFORD EXHIBITION
C.C. SERIES 86

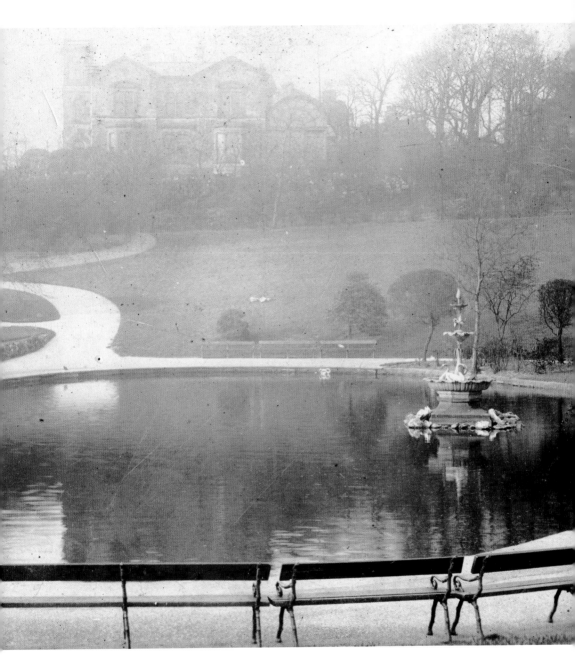

Lister Park
The lake in Lister Park. (Historic England Archive; Paul Chrystal)

*Above*: Piano Display
A wonderful floral display depicting a grand piano. (Historic England Archive)

*Below*: Peel Park
Peel Park is Bradford's first public park and opened in 1853. Its 56 acres are named after Sir Robert Peel (1788–1850). In 1902 an ornamental bandstand was erected along The Terrace but today the statue of Sir Robert Peel stands there. (Historic England Archive)

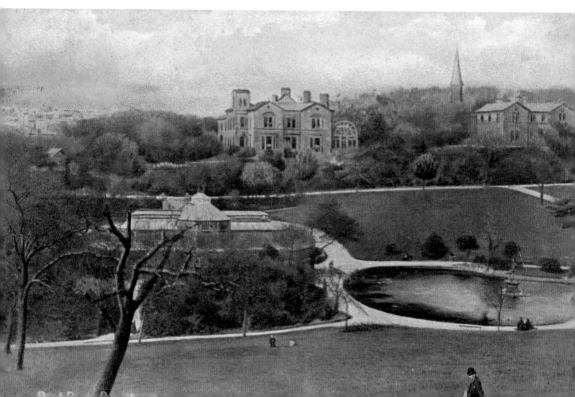

# People

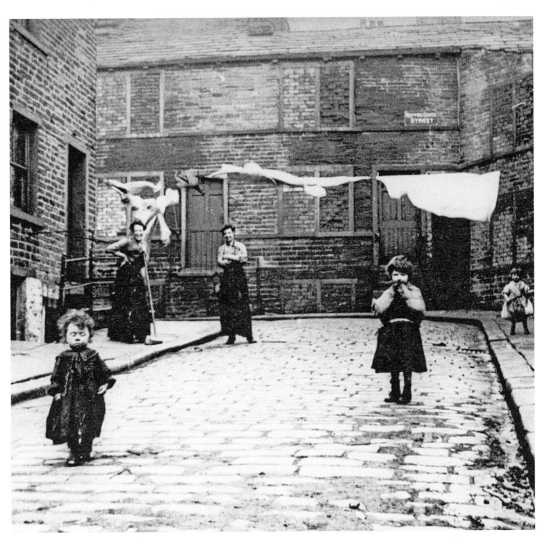

Life in Early Bradford
A typical scene of poverty in early twentieth-century Bradford. (Paul Chrystal)

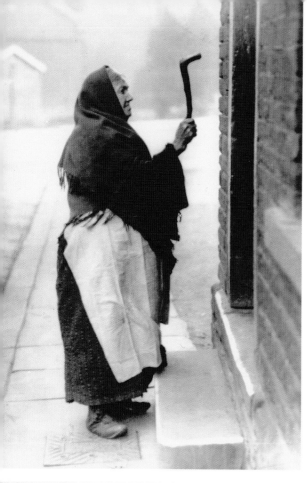

*Left*: Waking Up the Locals
A Bradford knocker-upper – early alarm clock technology. Of course, the question on everyone's lips is 'who knocks up the knocker?' (Paul Chrystal)

*Below*: 'The Morning Wash' – Bradford's Back to the Land Pioneers during the First World War
The various 'back to the land' movements encouraged people to take up smallholding and to grow food from the land either for themselves or for third parties. (Paul Chrystal)

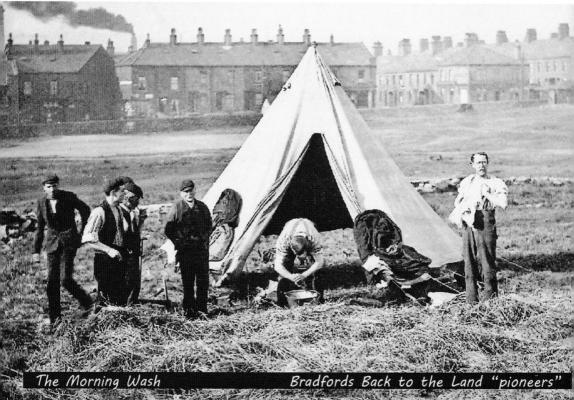

The Morning Wash                    Bradfords Back to the Land "pioneers"

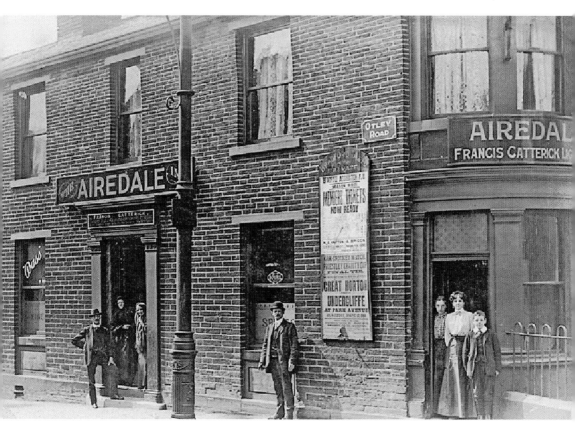

Airedale
Customers and the licensee with family outside the Airedale in the Otley Road. Paul Jennings describes the Airedale in *The Local: A History of the English Pubs*:

A licence was granted to Thomas Peel for the newly-built Airedale Inn in 1848, chiefly because of its stabling, according to the magistrates ... The photograph shown here was taken in 1910, the year that Francis Catterick and his wife Sarah had taken the pub. The posters on the wall between them advertise that members' tickets were now available for the Bradford Amateur FC, season 1910-11, and that the forthcoming final of the Priestley Cup would take place at Park Avenue between Great Horton and Undercliffe, which the latter went on to win by 118 runs. The Cattericks were to remain at the Airedale until the summer of 1921 ... Under the Cattericks it had been a free house, selling both Tetley and Hammonds beers, but eventually became a Tetley's house. It was this brewery which built a new Airedale as part of the clearance and redevelopment of the area in the late 1950s and early 1960s. This was set a little further back than the original pub, on the site of Airedale Place, partly to allow room for a car park. (Paul Chrystal)

# Saltaire

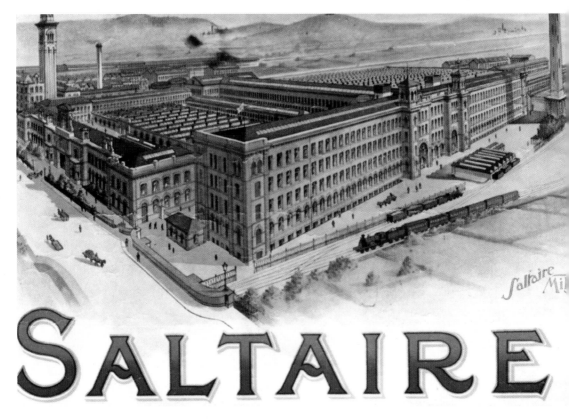

Saltaire Mill
Saltaire Mill was completed in 1853 and New Mill was completed in 1868. (Paul Chrystal)

*Opposite*: Almshouses, Nos 50–64 Victoria Road
These images shows the almshouses along with the central bay and bell turret in 1992. The forty-five almshouses in Saltaire were completed in 1871 in Venetian Gothic style – all but two are of a single storey. Selected villagers were given free accommodation and a weekly pension of 7*s* 6*d* for a single person or 10*s* for a couple – exceeding the amount given under the 1908 national Old Age Pension Scheme by Asquith. (© Crown copyright. Historic England Archive)

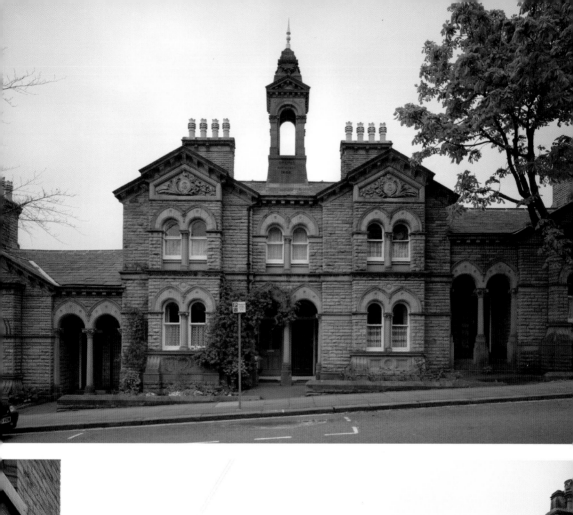

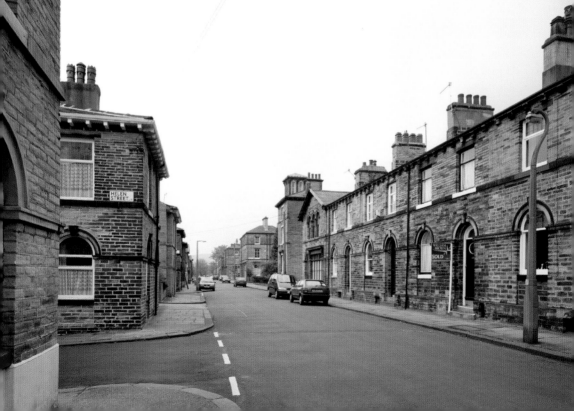

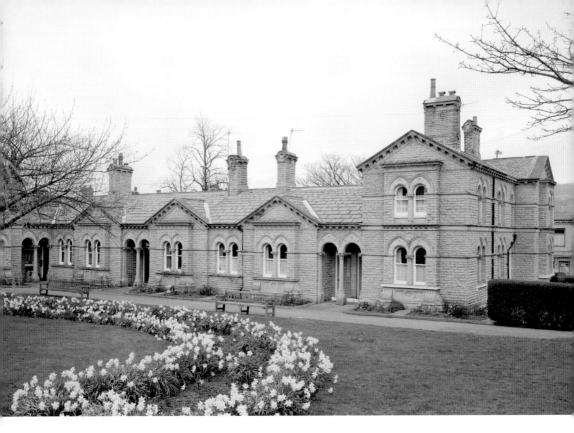

*Above*: Almshouses, Victoria Road

Saltaire was the first sizeable British model village to serve an industry. Titus Salt, its founder, was evidently influenced by Disraeli's novels *Coningsby* and *Sybil* (particularly by Mr Trafford). The driving force, though, was surely a desire to achieve efficiencies on the shop floor with a productive plant and a contented workforce – in short to maximise profits while satisfying a desire to improve the social and industrial welfare of his workers. Bournville for the Cadbury workers, Port Sunlight for the Lever workforce and New Earswick near York (a mixed community for Rowntree workers and others) all followed suit. (© Crown copyright. Historic England Archive)

*Opposite above*: Salt's Mill and New Mill on Either Side of the Leeds and Liverpool Canal

Sir Titus Salt (1803–76) was one of nine children of Daniel and Grace Salt, both fervent Congregationalists. Saltaire is a conflation of 'Salt' and 'Aire', the river on which the town stands. Salt moved his existing mills from Bradford, consolidating it all on this site so as to be close to the Leeds and Liverpool Canal and the Midland Railway. (© Crown copyright. Historic England Archive)

*Opposite below*: Salt's Mill from Victoria Road

Salt was born in Morley. After education at Batley Grammar School he started work as an apprentice wool-stapler in Wakefield, moving on to William Rouse & Son in 1822, and then in 1824 he joined his father as wool buyer and partner in Daniel Salt & Son, wool-staplers, in Bradford's Piccadilly. He took over the business in 1833 when his father retired and by 1853, as a worsted stuff manufacturer using the somewhat intractable Donskoi wool from southern Russia, he became the largest employer in Bradford. His factory workers were augmented by numerous outworkers combing and weaving in their homes in Little Horton, Baildon and Allerton. (© Crown copyright. Historic England Archive)

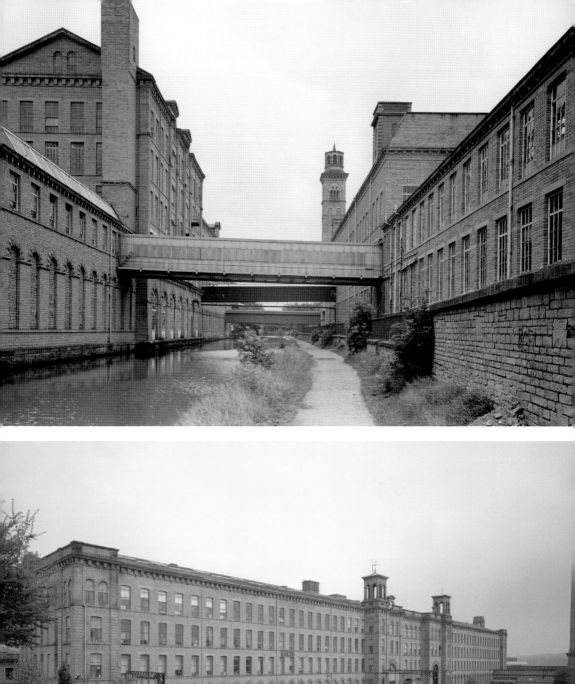
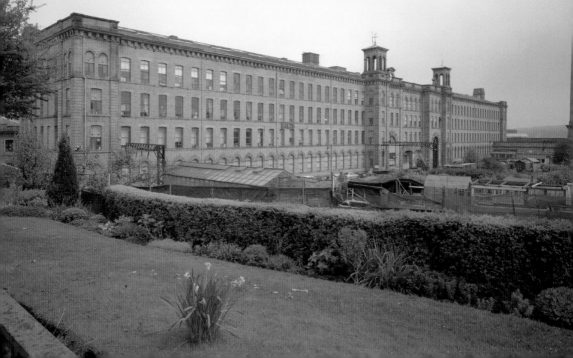

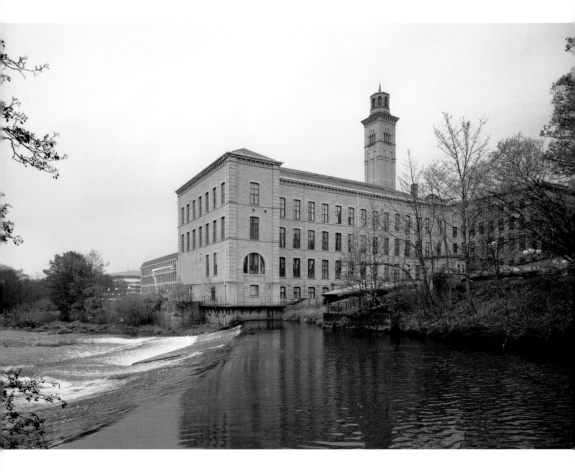

*Above*: New Mill from Across the River Aire
Always innovative, in 1836 Salt began to use alpaca wool and created the fashionable 'alpaca' cloth known as Orleans cloth, which was highly sought after for ladies' dresses. In 1837 he was working with the lighter, more elegant and versatile mohair and cotton warps. Charles Dickens describes how Salt came upon it at CW&F Foozle & Co. in a story in his magazine *Household Words*: Queen Victoria sent him the wool from her two alpacas to make into cloth for her dresses. By 1845 Salt had made his fortune. (© Crown copyright. Historic England Archive)

*Opposite*: The United Reformed Church (formerly the Congregational Church)
Salt died in 1876 and is buried at Saltaire Congregational Church; a reputed 100,000 mourners lined the funeral route. The Congregational Church, designed in the classical style, was intentionally sited so that it was highly visible from the mill. Built in 1859, it was, significantly, Salt's first public building.(© Crown copyright. Historic England Archive)

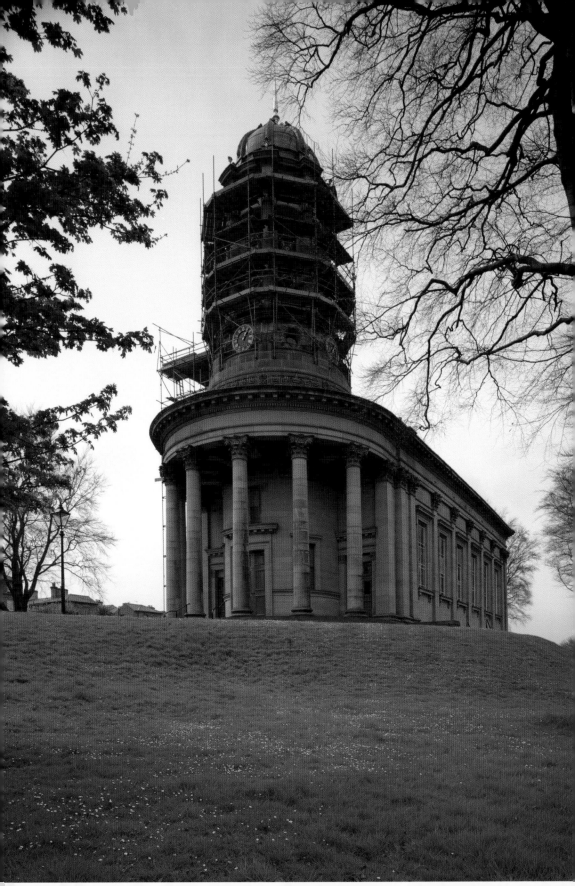

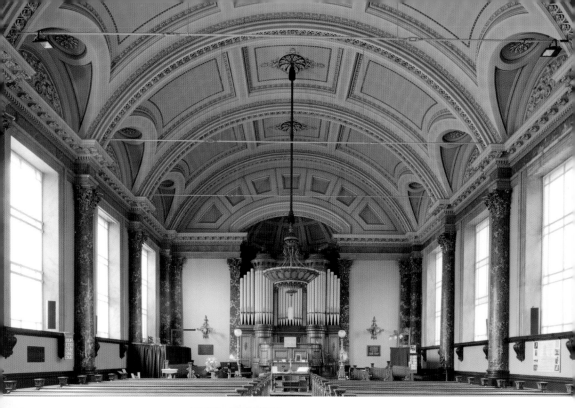

*Above*: The Fine Ceiling of United Reformed Church
The United Reformed Church seated 600 worshippers and regularly held congregations, making it at least two-thirds full. The Salt family mausoleum is close by, which holds the resting place of Titus Salt, Lady Salt and other members of the family. (© Historic England Archive)

*Left*: United Reformed Church
The wooden bench ends of parallel seating in the church. (© Historic England Archive)

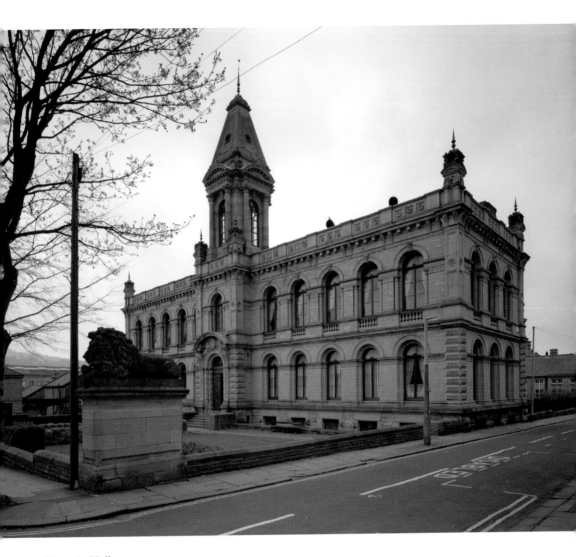

Victoria Hall

Victoria Hall (formerly the Institute) is seen here in 1998 – the social hub of Saltaire. Officially named the Saltaire Club and Institute, it was finished in 1871 at a cost of £25,000. It comprised a reading room and library, a chess and draughts room, a smoking room, science laboratory, a billiard room, a lecture theatre seating 800 people, a concert hall, drill hall and rifle range, and a gym – all heavily subsidised for residents. Outside in Victoria Square the gates are guarded by four splendid lions – rejected by Nelson for Trafalgar Square but resplendent here. They represent war, peace, vigilance and determination.

The Victoria Hall still hosts various events under the beautiful ceiling. Over the years speakers have included John Ruskin, Benjamin Disraeli and David Livingstone. Charles Dickens was booked to speak just before his death in 1870. More recent speakers have included Paul McCartney, Tony Blair and Prince Charles. (© Crown copyright. Historic England Archive)

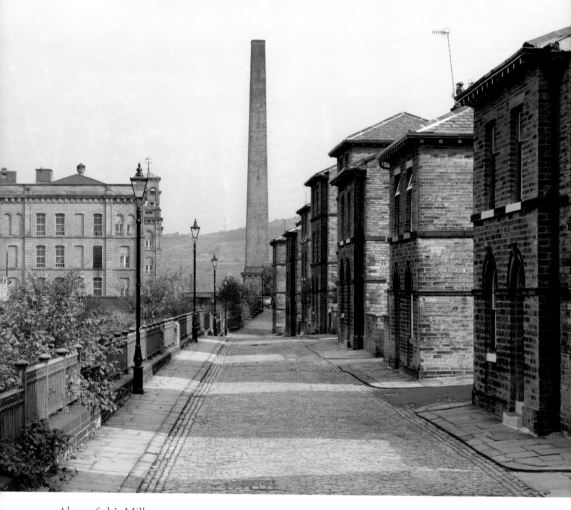

*Above*: Salt's Mill
Seen here from Albert Terrace in 1986. (© Crown copyright. Historic England Archive)

*Opposite*: Sir Titus Salt
The statue of Sir Titus Salt in Roberts Park, with Saltaire in the background. It is well known that Salt named many of his streets after his family: Albert, Caroline, Fanny, etc. Titus Street, unsurprisingly, was the epicentre of the village. No. 47 was in the middle of this street, which is where the mill's security officer, Sgt-Major Hill, lived. His viewing tower was set into the roof and from here he could observe most of the village, although the purpose of the tower was probably just to serve as a firewatch. (© Crown copyright. Historic England Archive)

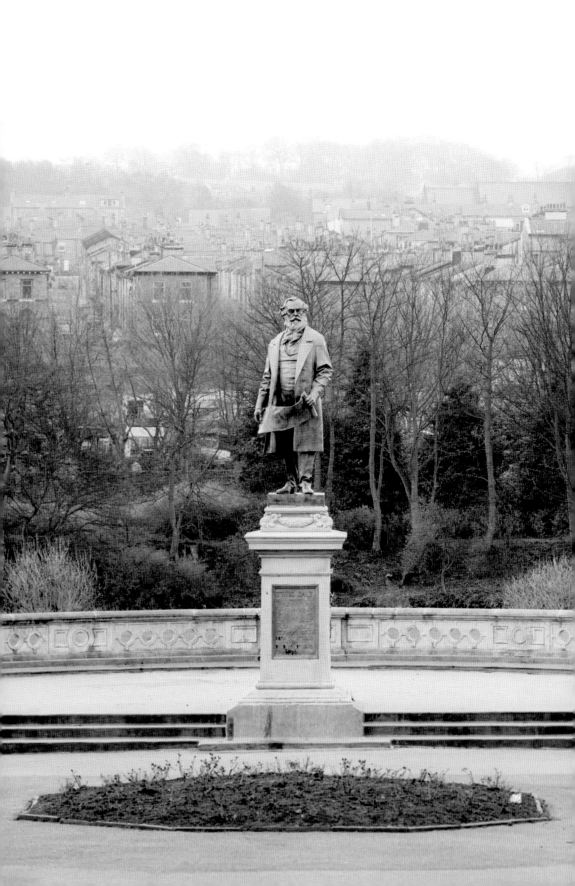

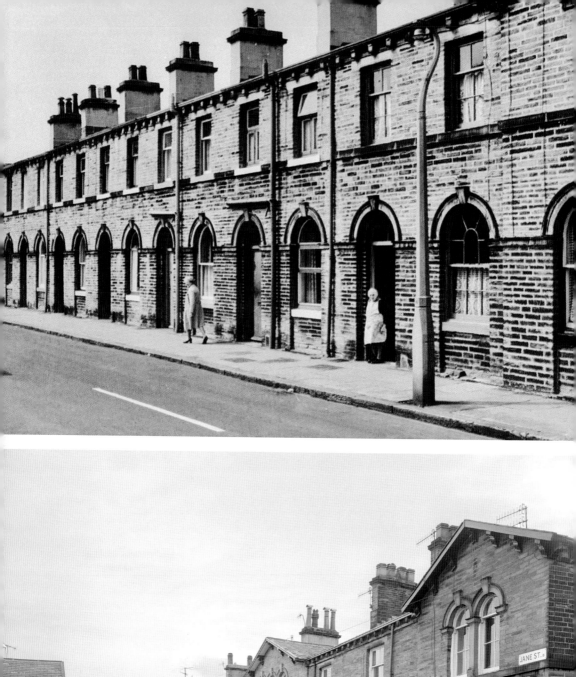
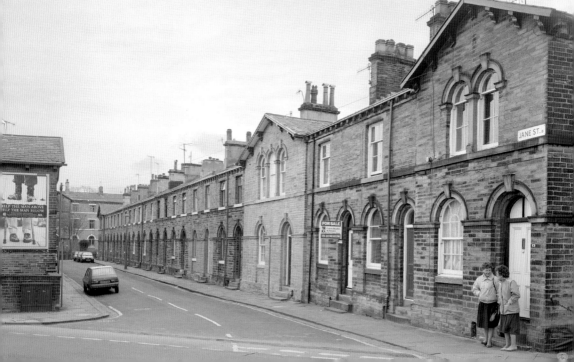

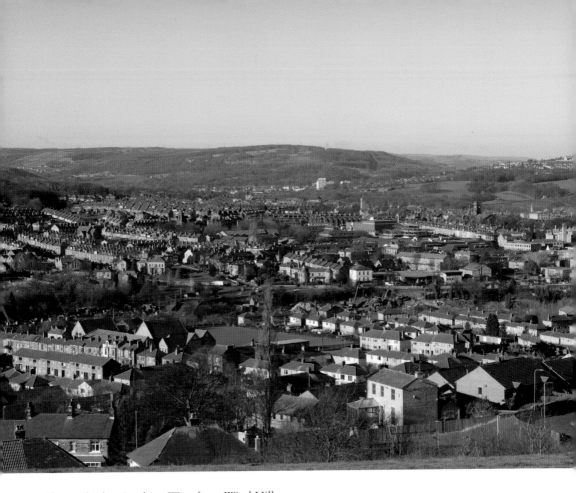

*Above*: Shipley, Looking West from Wind Hill
Neighbouring Shipley came alive with the Industrial Revolution, capitalising on water and steam power to drive its mills, notably for the burgeoning wool, spinning and weaving industries. Boots, nails and bricks were also made here, while the twenty or so quarries in the vicinity made quarrying and building another significant local industry. As with other growing industrial towns, though, Shipley quickly became everything that Saltaire was not: overcrowded, polluted, unsanitary and a reservoir for deadly diseases such as cholera, scarlet fever, smallpox and malnutrition. (© Historic England Archive)

*Opposite*: Workers' Cottages
The second view shows the terraced workers' cottages on the south side of Jane Street. The houses in Saltaire covered 25 acres, and the population in 1871 was 4,389. The type of house you were assigned corresponded to where you were in the social hierarchy. Workers had two bedrooms, a living room, cellar pantry and a kitchen – all basically decorated. Overlookers had three bedrooms, a sitting room, scullery kitchen, cellar and a small front garden – decorated in early Renaissance style. There were three-storey houses in Albert and Caroline Streets intended as lodging houses. The baths and washhouses were at the top of Amelia Street. Houses and streets in Saltaire were a world away from what residences had endured in Bradford or Shipley. There was a drainage system, a private backyard with a residents' toilet; the streets were open-ended and exposed to air and sun; and water and gas was supplied to every house. (Paul Chrystal; © Crown copyright. Historic England Archive)

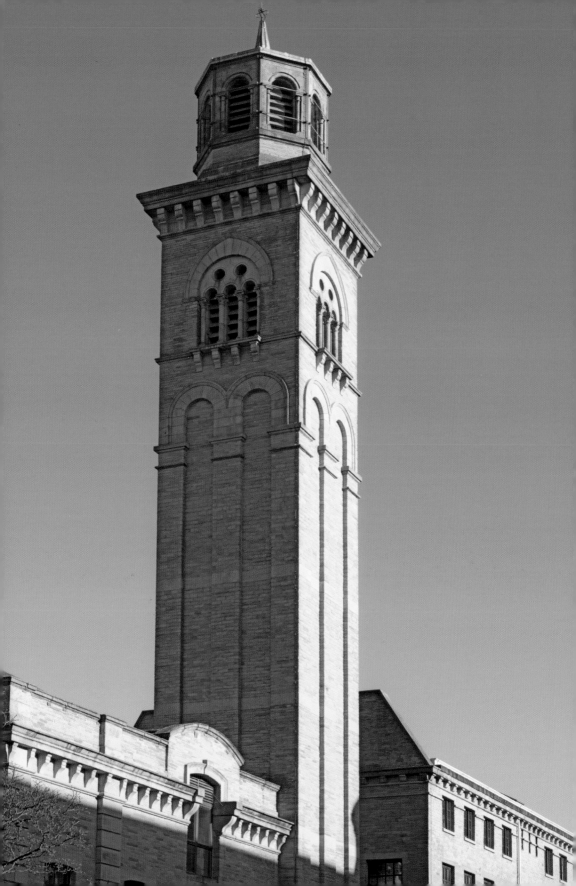

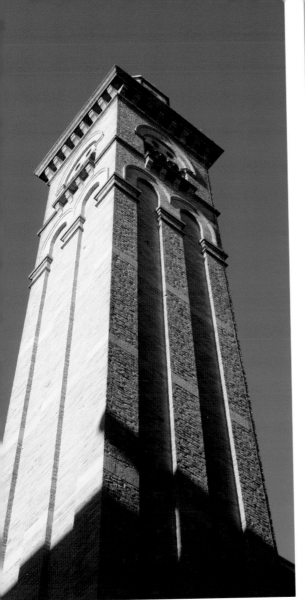
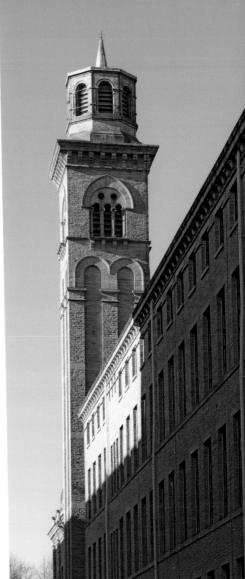

*Above and opposite*: New Mill Chimney

The impressive campanile must be one of the most aesthetic chimneys ever to be built. It is based on the campanile on the Basilica Santamaria Gloriosa in dei Frari in Venice, which towers above the Campo dei Frari in the San Polo district. The campanile, the second tallest in the city after San Marco's, was completed in 1396 and is home to masterpieces of religious art. (© Historic England Archive)

# About the Archive

Many of the images in this volume come from the Historic England Archive, which holds over 12 million photographs, drawings, plans and documents covering England's archaeology, architecture, social and local history.

The photographic collections include prints from the earliest days of photography to today's high-resolution digital images. Subjects range from Neolithic flint mines and medieval churches to art deco cinemas and 1980s shopping centres. The collection is a vivid record both of buildings that are still part of everyday life – places of work, leisure and worship – and those lost long ago, surviving only in fragile prints or glass-plate negatives.

Six million aerial photographs offer a unique and fascinating view of the transformation of England's towns, cities, coast and countryside from 1919 onwards. Highlights include the pioneering photography of Aerofilms, and the comprehensive survey of England captured by the RAF after the Second World War.

Plans, drawings and reports provide further context and reconstruction artworks bring archaeological sites and historic buildings to life.

The collections are housed in a purpose-built environmentally controlled store in Swindon, which provides the best conditions to preserve archive items for future generations to enjoy. You can search our catalogue online, see and buy copies of our images, as well as visiting our public search room by appointment.

Find out more about us at HistoricEngland.org.uk/Photos
email: archive@historicengland.org.uk
tel.: 01793 414600

The Historic England offices and archive store in Swindon from the air, 2007.